KINGDOM'S
BOUNTY

A SUSTAINABLE, ECLECTIC, EDIBLE
Guide to VERMONT'S NORTHEAST KINGDOM

KINGDOM'S
BOUNTY

A SUSTAINABLE, ECLECTIC, EDIBLE
Guide to VERMONT'S NORTHEAST KINGDOM

By Bethany M. Dunbar
Introduction by Bill McKibben

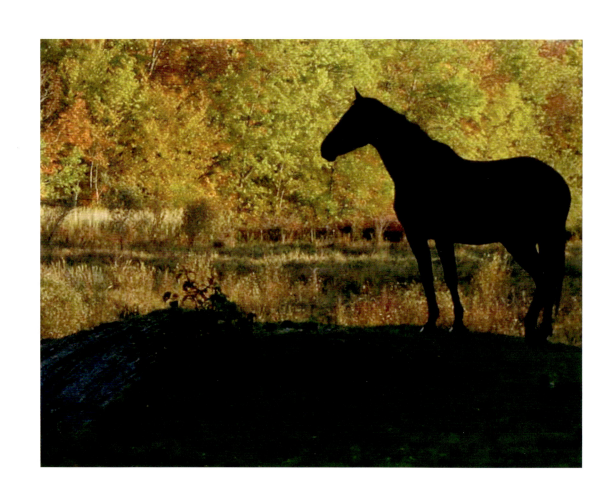

dedication

I'd like to dedicate this book to my father, Addison Hoyt Merrick, for expecting a lot from me; to my mother, Helen Ellis Merrick, for saying I was always doing great; to my little sister, Ann Harrington, for looking up to me; to my sweetheart, Jim Bowes, for keeping my head on straight; to my grown children, Tristan and Katie, for making my heart sing; to the Dunbar clan, for keeping me part of the family even after the divorce; and to all the once and future farmers of the Northeast Kingdom for making this place what it is.

– BETHANY M. DUNBAR

To John and Nancy Richardson, my parents, who visited the Kingdom in 1969, felt the connection, and put down roots; to Joan, Martha, Mary, John, Eithne, and Thomas Richardson, their wives, husbands, partners: Juan Cameron, Sally Harvey, Temple Dunlap Smith Richardson, Kyra Cheremeteff, Robert F. Kennedy, Jr., Andrew Karsch; and to our children: Olivia Skye Cameron, Conor Kennedy, Emma Ward Cameron, Kate Richardson, Kyra Kennedy, Luke Cameron, Ali Richardson, Finn Kennedy, Andrew Richardson, Otis Richardson, Aidan Vieques Kennedy, Isabella Augusta Karsch, and James Richardson Karsch.

– NAN RICHARDSON

Table of Contents

Emma Sestito made three new friends at a pasture walk, for farmers to learn about pasture management, at the Boutin Farm in Newport Center.

the keys to the kingdom

The Northeast Kingdom includes the wildest and woolliest parts of Vermont—specifically Orleans, Caledonia, and Essex counties—a dreamscape of mountains, lakes, wildlife, hills, forests, villages, and farmland. With thousands of acres of deep forests, it is also Vermont's "lakes country," home to over thirty lakes and ponds, each more beautiful than the next.

They say the name came from the revered Vermont Senator George Aiken who, overcome with the area's sheer beauty, declared, "It should be called the Northeast Kingdom." This sentiment resonated; it is indeed God's country. The Northeast Kingdom has always been rich in forestry and agriculture, but its tradition of dairying is changing. Now, fewer cows graze in the green pastures. What has emerged instead is a rich food culture, grown organically from the Kingdom's tradition of amazing bounty from the blackest, richest soil in the country, where the growing season from June to first frost is short, but so sweet.

Growing up on Telfer Hill Road, all my neighbors had bumper gardens, vying for blue ribbons in the annual fair with tomatoes, heirloom beans, beets, and chokecherry jelly. Arlene Simon, Germaine Healy, and Florence May had extravagances of vegetables and flowers. What they couldn't eat they canned for the winters ahead. The church suppers were amazing—often ending with the local delicacy, sugar on snow. Ms. Urie in Glover made chicken pot pies for campers on Friday nights, and my large family of nine booked a standing order for three large pies weekly (or else they'd be gone in a flash) and looked forward to them all week. We drank raw milk with four inches of yellow cream on top from neighbors Rupert and Muriel Chamberlain's prize-winning cows in their spanking-clean milking parlor. Nothing tasted as good as that milk.

I recall reading about Thomas Keller's new California restaurant with its $500 prix fixe and year-long wait-list. Keller boasted that his butter and cheese was flown in daily from four Vermont Jersey cows—Flossie, Flora, Fergie, and Fannie—who lived delicately in gorgeous alpine meadows and feasted on delicious organic green grass. ("But," I thought with a shock, "*all* Vermont cows live that way!"). The local food is famed for its wholesomeness, nutritional value, freshness, and high

quality. The folks in the Kingdom have always known the way to eat well.

There was, and is, a lot more than food happening up here in this real-life Never Never Land. It has always been a Mecca for people who need light and solitude and time—artists and writers, sportsmen and sportswomen, musicians. Indeed, lately there has been a lively surge in theater, museums, and galleries. And, of course, it has always been prime territory for the outdoorsman, a place to explore nature up close: hiking the mountains, biking the lovely byways, swimming and paddling the wild rivers and lakes, skiing, skidooing, hunting, fishing, and camping. It is all backroads, funky signs, and secret wonders. It can be hard to access, and much goes on by word of mouth. GPS doesn't work here, and cellphones barely do. It's a place of oral, lived history. It's a place for the discerning who don't like showy and who do like authentic. It's the antidote to "civilization." Above all, it's a place where, as in the Yeats poem, "peace comes dropping slow." You have to give that time-out-of-time feeling room to seep in, filling you slowly with its sweet-smelling magic. Even the air is soft. You have never slept better in your life than in a downy bed in the Kingdom on a cool August night.

This guide hopes to introduce the energetic, committed, ideas-a-popping people that are bringing the Kingdom into a new era of glory, one that is, at its core, a return to the region's finest traditions, grounded by a philosophy of preserving its community's rural identity and lifestyle, keeping Vermont farms working, and keeping green spaces open. Along the way, they and their fellow Vermonters are reaping the economic benefits of supporting local businesses. So come explore with us, as we hope to share some of the best-kept secrets—the keys to the Kingdom—with you!

—Nan Richardson, Editor

A maple sugarbush shows off its fall colors. The blue pipeline will be full of sap in the early spring, to be boiled down into maple syrup at a nearby sugarhouse.

introduction
by Bill McKibben

These remarkable images tell an even more remarkable story—the way that the most rural region (sometimes dismissed as a backwater) of the most rural state in the union is leading a revolution in American agriculture—a revolution that, if we're lucky, may someday help refashion the ruinous way we're growing and eating food in America.

Some of us are lucky already, of course. If you live in Vermont, these are not just names of agricultural pioneers, but the names in your refrigerator. I have Butterworks Farm yogurt almost every morning—it's nice to have visited the happy cows. Lazy Lady cheese is a special occasion treat. The new Hill Farmstead brewery is suddenly producing hoppy ales the equal of anything in Oregon.

But they're also producing another commodity, and that's community. Early in 2011 the barn at Pete's Greens burned to the ground. They were underinsured, out almost $250,000. But in the scheme of things, it could have been worse. People rallied from across the region and around the state, sending in contributions and bidding on hundreds of donated items at an online auction. It was a reminder that almost everyone understands that this is about much more than business—it's about making a place that works, where there's some resilience, some security, and some durability.

There are a few other places around the country where the same revolution is gaining steam: the Pacific Northwest, parts of the upper Midwest, regions of Maine. But there's no concentration equal to that of the Northeast Kingdom; just to sit in Claire's Restaurant in Hardwick is to feel it, with everything from the Farmstead Beer to Vermont Soy's tofu to Pete's Greens to Jasper Hill Cheese, all of which comes from local producers. They have High Mowing Seeds in town to provide the start to the process, and they have the Highfields Institute in town to show everyone how to compost what's left over.

Hardwick's example is spreading around Vermont, as newly elected politicians try to figure out how to make sure slaughterhouses and food processing facilities spring up elsewhere. And it's spreading around the nation, as one food magazine after another comes calling. But the real influence is on all of us who get to take part in this experiment, if only as eaters who get to feel, three times a day, like participants in something inspiring, fresh, and possible. It's hard to overstate the pleasure: a glass of beer, a slab of cheese, and a ray of hope.

on finding food that satisfies

by Bethany M. Dunbar, locavore

More and more, I find myself driving around the Northeast Kingdom to find my favorite cheeses and beer, the colorful and delicious beets at Pete's Greens, a pint of blueberries from Brown's, my gallon of raw milk for the week from my neighbors, thick slabs of locally smoked bacon, or a pound of beefalo hamburger from Farm to Forest to grill for dinner.

As a journalist with a background in dairy farming, I have a perfect excuse to visit farmers and farmers' markets, the best food stands, the people who make relish, and those who grow garlic. I love taking their pictures and writing about them for the local paper, *The Chronicle*, because it helps the farmers sell products and helps the reader find delicious, naturally farmed food.

I understand the hard work and satisfaction involved in farming from my own eleven years milking our beautiful Jersey cows, first in Barton and later in Craftsbury. Back then, it was a frustrating time financially, and today things are no easier for dairy farmers shipping to the conventional market. Milk prices are out of conventional farmers' control due to a convoluted and outdated federal pricing system. Our congressional delegation, the Vermont Agency of Agriculture, along with many other farm advocates, are doing everything they can to help dairy farmers get a fair price. Whether they can do so in time to prevent the further erosion of our statewide industry is still in question.

Meanwhile, many of those same farmers aren't waiting for government solutions but instead finding ways on their own to diversify, locate new sources of revenue, and innovatively add value to their operations. More and more farmers are making milk into cheese, opening their farms to tourists, selling direct to visitors, and "going organic" in order to take advantage of consumers' desires for food that is healthier. Some farmers are tackling energy issues head-on: installing methane digesters to convert manure gases into electricity; adding small wind towers; or looking into hydro, solar, and geothermal energy sources. All this helps the farmers economically and shows their respect and care for the land.

There is good news in the rural agricultural economy of Vermont these days, and it is all thanks to the Yankee ingenuity and rugged determination of people who are continually finding ways to make ends meet and keep their land in farming and their fields open.

I should mention that this book comes with a "WARNING: DANGER" sign. Once you have tried the cloth-bound Cabot cheddar, the Jasper Hill and Lazy Lady cheeses, fresh local eggs, tomatoes, lamb chops, and maple ginger candy from Deep Mountain Maple, you won't want to go back to the mass-produced, preservative-filled, nutritionally-suspect stuff shipped 3,000 miles across the country and colored with dye to give it the illusion of ripeness.

I was sharing with a friend the realization that the local food movement in the Northeast Kingdom is not a huge leap or shock to the system on a local level because it is such an integral part of who we are and have always been. Barely a generation removed from the days when everyone grew their own food or traded with neighbors to fill the Thanksgiving table, we in the Kingdom can simply ask our grandparents for recommendations about the best pie apples, where to gather edible wild plants, or how to make delicious pickled dilly beans.

This book, then, is just an extension of the work I have been doing for twenty-five years, telling these local stories. My hope is that our quirky guidebook will help tourists and consumers find the best products the area has to offer and get to know the admirable farmers who grow and make them. This, in turn, will lead to more and better for all of us who love Vermont.

Thanks so much for reading and for supporting local food, farmers, and your local newspaper!

The Kingdom's Bounty

Canada
United States

Beebe Plain
Exit 29

Jay State Forest

Averill

Wallace

Great Averill Pond

Forest Lake

Black Turn Brook State Forest

Lake Memphremagog

Bill Sladyk W.M.A.

Holland Pond

105

105

242

Jay Peak

Jay State Forest

101

100

Newport

Derby Center
Derby

Clyde Pond

Lake Salem

Little Averill Pond

Notch Pond

Westfield

5

91

West Charleston

111

Seymour Lake

114

102

ORLEANS

Exit 26

Brownington

Brownington Pond

Echo Pond

East Charleston

Island Pond
Grand Trunk Railroad Junction

ESSEX

58

Island Pond

Brighton State Park

Silvio O. Conte National Fish and Wildlife

Irasburg

Orleans

Westmore

Lake Willoughby

Willoughby State Forest

Long Pond

Bald Hill Pond

105

Barton

Crystal Lake

114

West Mountain Wildlife Management Area

Maidstone Lake

Albany

Lake Parker

Exit 25

Glover

Willoughby State Forest

Newark Pond

Center Pond

Maidstone State Park

100

Black River

South Pond

South Albany

Daniels Pond

Shadow Lake

16

Lake Eden

Green River Reservoir

14

Craftsbury

Lake Eligo

122

Sheffield

Mathewson State Forest

Darling State Park

East Burke

Darling State Forest

Victory State Forest

LAMOILLE

Caspian Lake

Greensboro

Flagg Pond

Wheelock

Exit 24

Chandler Pond

Victory Basin W.M.A.

Wolcott Pond

Steam Mill Brook W.M.A.

Lyndon

Lyndonville

Wolcott

Hardwick Lake

East Hardwick

Exit 23

Bag Balm Headquarters

Neal Pond

Hardwick

12

15

CALEDONIA

Great Vermont Corn Maze

5

Fairbanks Museum & Planetarium

2

Lunenberg

Miles Pond

WASHINGTON

Walden

2

St. Johnsbury

14

Cabot

2

American Society of Dowsers

Danville

Joe's Pond

Exit 19

Stiles Pond Reservoir

Moore Reservoir

Peacham

Marshfield Pond

Peacham Bog

West Barnet

Groton State Forest

Harvey's Lake

5

93

Exit 43

Exit 42

Barnet

Exit 40

Bethlehem

2

Corinth

89

3

10

302

Miles
0 3

North

GUIDED TOURS

Monday

Start the tour at the award-winning **Cabot Visitors' Center**, where you can see cheese being made. Sanitary conditions at cheese-producing facilities must be strictly controlled due to the possibility of contamination from outside bacteria, and therefore smaller cheesemakers are not set up to allow visitors. At Cabot, you can witness the process firsthand and sample the final product.

Tuesday

If you're traveling in summer, stop at the **Red Sky Trading Company** in Glover to purchase local cheeses. Head north on Route 16 to Westmore, then to Route 5A, and turn left on Sanderson Hill Road, where you will find **Eden Ice Cider**. Ice cider is a dessert wine that pairs well with cheeses, savory hors d'oeurves, and buttery desserts. Eden makes theirs using traditional and heirloom varieties of apples grown in Vermont. From here, take Route 5A back to Westmore and stay at the **Willoughvale Inn**. Or, if you are in the mood to explore the back roads, head to West Glover and stay at the **Rodgers Country Inn**.

Wednesday

Make a trip to **Hill Farmstead Brewery**, open Wednesdays through Saturdays, 12 pm to 5 pm. While in Greensboro, stop at **Willey's General Store** for a variety of local cheeses and wines, including selections from **Jasper Hill** and **Ploughgate Creamery**. To get to Hill Farmstead from Willey's General Store, head north on Lauredon Avenue past the Town Clerk's office and Lakeview School. Take a right at the Y on Baker Hill Road, bear left on Town Highway 8, and take the next right on Hill Road. Hill Farmstead Brewery will be on your left.

Thursday

Head to **Parker Pie** in West Glover for music night, where you can nosh on pizza and sample local microbrews on tap. If you want to travel the scenic route from Greensboro, take Craftsbury Road to East Craftsbury, then take South Albany Road to Andersonville Road, which turns into County Road, which then takes you to Parker Pie. For an alternative route on the main road, take Route 16 toward Glover and then travel up Bean Hill Road to Parker Pie.

Friday

Make a stop at the **Hardwick Farmers' Market**, where you can find Jasper Hill cheese, local produce, and maple syrup. Continue on to **Buffalo Mountain Co-op and Café** for grass-fed beef, artisanal coffee and tea, and Lazy Lady cheese.

Saturday

Pick up raw sheep's milk cheese from **Bonnieview Farm** at the **Craftsbury Farmers' Market**, where you can find a variety of local specialties and crafts.

Sunday

Drive north to Newport to see Lake Memphremagog and stop at **Newport Natural Foods** for more local cheeses. Newport Natural is the oldest continuously operated natural foods store in the North Country. Plan a picnic at **Prouty Beach** if the weather is warm, or a snowshoe hike if you go during the winter months.

September Foliage Tour

Vermont is known for its spectacular fall foliage. Prime leaf-peeping season occurs from late September through the third week in October, as the leaves turn from green to shades of gold and vermillion. Peak viewing time varies slightly from year to year, though mountain tops and northern areas turn before the valleys and destinations farther south.

Monday

Take 114 south to Island Pond, then Route 100 to Lowell and then Hazen's Notch Road, which meanders through Montgomery, Richford, and Jay. The Hazen's Notch Road is narrow and winding, so much so that it's closed in the winter. Spend the night in Jay, where you can find accommodations at the **Tram Haus** and dine at **Alice's Table**.

Tuesday

From Jay, take 101 to Troy, then 100 to Lowell, then Route 58 east to Orleans, and then Churchill Road to Hinman Road to find the **Old Stone House Museum** in Brownington, which houses exhibits focused on nineteenth-century life in northern Vermont. Stay at the Willoughvale Inn located on the scenic shores of **Willoughby Lake** in Westmore.

Wednesday

Hike up Mount Pisgah or Mount Hor on the opposite side of lake, or relax with a picnic on the beach.

Thursday

The Willoughby Lake Farmers' and Artisans' Market is open on Thursdays from 3 pm to 7 pm in Westmore.

Friday

Check out hikes or mountain bike tours at **Kingdom Trails** in Burke, which was named Best Trail Network in North America by *Bike Magazine* and Best of New England by *Boston Magazine Travel & Life*.

Saturday

Start your tour in St. Johnsbury, where you can visit the **St. Johnsbury Farmers' Market** and purchase provisions for your journey. From there head up Route 2 to Route 102 north to Canaan along the Connecticut River, then west on 114 to Forest Lake Road and on to Quimby Country in Averill. This drive will take you through some of the most beautiful and remote parts of Vermont.

Sunday

Take a hike and picnic at **Quimby Country**, a family resort in the Great North Woods Forest that has been operated for over 100 years. Stay overnight at one of their rustic cottages, each equipped with a porch overlooking Forest Lake.

March Maple and Ski Tour

The best time of year to plan your maple and ski tour is during the middle of March, when Vermont hosts its maple open house weekend. Go to www.vermontmaple.org to find a listing of the open sugarhouses by county, along with other information.

Monday

Visit **Maple Grove** in St. Johnsbury, where you can tour the Sugar House Museum and stock up on maple candies, syrup, and other Vermont-made products at the Cabin Gift Shop. Call ahead to make sure the museum is open.

Tuesday

Hit the slopes at **Burke Mountain**, where they offer both Nordic and Alpine skiing.

Wednesday

Stay at the **Craftsbury Inn**. From there, cross-country ski trails lead over to the **Craftsbury Outdoor Center** or **Highland Lodge trails**.

Thursday

Head to **Jay Peak** for skiing and snowboarding, or go skating at the resort's **Ice Haus Arena**.

Friday, Saturday, and Sunday

Spend the weekend touring the area's maple farms, planning your stops depending on the sugarhouses' availabilities. Be sure to try "sugar on snow," a traditional Vermont treat made by pouring maple syrup over snow, where it then turns into a sticky treat. It's often served with dill pickles.

Jed's Maple in Westfield is a particularly good place to visit. This family-run farm owned by the Wheelers offers exceptional open houses. In past years they've showcased a "tree and track" trek with **Siskin Ecological Adventures**, wood-fired organic pizza, and an ice cream social at their open house. In addition to maple syrup and candy, they make award-winning mustard, salad dressings, horseradish sauce, and pancake mixes.

Another worthwhile destination is **Couture's**, a working maple and dairy in Westfield that offers a true Vermont farm bed and breakfast experience.

If you're in the mood for live music, visit **Sweet Stone Maple Farm** in Hardwick. They host a bluegrass band during their open house.

August Farm Tour

The Vermont countryside is dotted with scenic farms, old barns, and doe-eyed Jersey cows. Take advantage of the many farms that offer stays and tours to visitors. At night, try the fantastic restaurants, which feature the bountiful regional produce.

Monday

Start your visit by staying at **Couture's**, a working dairy and maple farm in Westfield. From there, journey to **Berry Creek Farm** located on Route 100 just south of Westfield, where you can purchase fresh strawberries, beeswax candles, and honey. The next stop is **Butterworks Farm**, nestled in the woods on Trumpass Road off of Buck Hill Road. Make sure to try their delicious organic yogurt. From here, a side trip to Newport is a good idea. Stop at **Newport Natural Foods** for a variety of local cheeses and other goods, then venture on to picnic by beautiful **Lake Memphremagog**.

Tuesday

Head to the **Derby Farmers' Market**, which is open Tuesdays and offers a variety of canned jams, pickles, fruits, and veggies. From there, you can drive down Route 5, taking a detour on Route 5A to see scenic Willoughby Lake. Back on Route 5, make a pit stop at **Evansville Trading Post** for beefalo burgers. From there, head south through Orleans to **Peak View Farm Stand** for corn. Keep going south on Route 16 to Glover, stopping at **Currier's Market** for Cabot butter, hamburger buns, and other supplies for a picnic at the beach the following day.

Wednesday

It's back to Barton for a beach day at **Crystal Lake State Park**, which has barbecue facilities and stunning views. While in Craftsbury, stop at **Pete's Greens' farm stand** for organic produce.

Thursday

Travel to Hardwick for a farm tour and dinner at **Claire's**.

Friday

Drop by **Caledonia County Fair** in Lyndonville, which promises plenty of activities for adults and children. Lodge at **Emergo Farm**, a working dairy farm in Danville. The Websters, who own and operate the place, might even let you help with farm chores.

Saturday

Check out the **St. Johnsbury Farmers' Market** and **Fairbanks Museum and Planetarium**. Treat yourself to a rustic yet elegant meal at **Elements**.

Sunday

Get lost in the **Great Vermont Corn Maze** in Danville, voted one of the ten best mazes in America. Grab dinner at the **Freighthouse Restaurant** in Lyndonville, where they are committed to using local and sustainable ingredients.

bonnieview

The Urie Family's Bonnieview Farm is a sheep dairy where award-winning cheeses are made.

Uries are everywhere on these back roads. They are farmers, selectmen, and school board members. They volunteer for fire departments, libraries, and churches. They bake the pies at church dinners and bring the casseroles when an older person is house-bound. Uries are cousins of Kinseys and Rowells, and when you put them all together, they comprise the core of Albany, Craftsbury, and parts of Glover.

The farm has been in the Urie family since Neil Urie's great-grandfather tilled the land. His father, Andy Urie, grew up there. His uncle Richard and his aunt Ellen milked its cows.

Neil Urie started out milking cows for the first two years that he ran the farm, but he choose to swap cattle for sheep after struggles with the commercial milk pricing system.

In 2001, Neil Urie and Kristin Erickson Urie met in the Craftsbury Community Care Center, apartments for people who can't live at home but don't need the full services of a nursing home. They weren't living there, but Neil's relative Albert was. Albert was a fan of Kristina's shape-note singing group, and thereby introduced Neil to Kristin.

"He kind of set us up," she says. In 2005, they were married.

Their daughter Tressa Fern came along in 2006. In 2009, she was joined by the triplets—Nell, Linden, and Maeda.

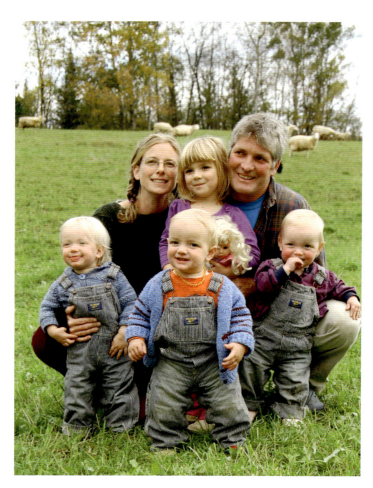

Recently, the Uries have focused on utilizing their clay oven to bake sourdough bread and to experiment with pizza recipes. Informal neighborhood pizza nights are a chance to get feedback on these recipes, as the Uries invite friends with only the most discerning tastes.

"The recipes are kind of a group effort," says Kyle Cunniff, who works on the farm. "We sit around and talk about ideas, what's in season, what's ready to be harvested." Some of the varieties include pizza with beets, curried beet greens, summer squash, and fresh basil.

"The sauce we make is all from home-grown tomatoes," says Cunniff. The star ingredient is, of course, cheese.

Urie creates a homemade ricotta, one of many fine, elegant cheeses in his repetoire. Mossend Blue is named after a place in the Uries' ancestral home in Scotland. It is hard in texture but smooth in taste, and not extremely salty—a conservative blue cheese that doesn't hit you in the face with its intensity.

Coomersdale has a nutty flavor, similar to Swiss—smooth, hard, and mild. Ben Bulbec is a majestic pyramid—like the Scots mountain it takes its name from.

The Uries also make a sheep's milk feta.

The source of all this goodness is the Uries' 170 sheep, which are milked seasonally from spring through mid-October.

"They're more skittish than cows. They're not as calm," Neil Urie says about his herd. "But in some ways they are easier to work with."

at a GLANCE

Bonnieview Farm sells cheese and lamb at the Craftsbury Farmers' Market, the Buffalo Mountain Co-op in Hardwick, and online. Bonnieview is not open to the general public, but arrangements can be made to purchase cheese by calling ahead.

*2228 South Albany Road
Craftsbury Common, VT 05827
bonniecheese@gmail.com
(802) 755-6878
www.ewemilk.com*

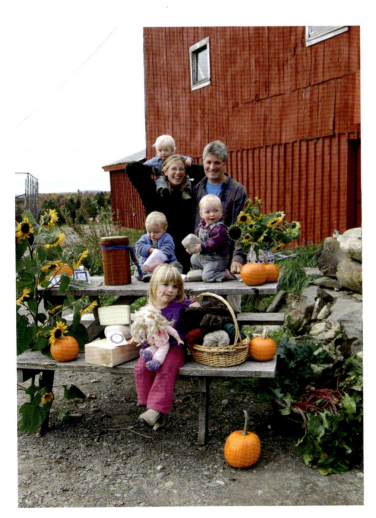

right: The Uries of Bonnieview Farm show off some of the cheese, flowers, and vegetables their farm produces. In back, Maeda is on Kristin's shoulders. Neil is at right. On the table are Linden and Nell, and in front is Tressa.

previous page: In front, left to right, are Maeda, Linden, and Nell Urie. In back are Kristin, Tressa Fern, and Neil Urie. Behind the Urie family are some of their milking sheep.

butterworks farm

Jack and Anne Lazor of Butterworks Farm in Westfield bring about real change—change for the good—in Vermont.

When the Lazors came to Westfield more than thirty years ago, organic dairy farming was a radical, fringe idea.

"We were organic and we didn't even know it. We just knew we didn't want to be regular," Jack Lazor says.

It's not so fringe anymore. Orleans County counts thirty-nine organic dairies, and about 200 out of 1,050 dairies in Vermont are organic. There is no doubt in my mind that every

single one of those thirty farmers saw what the Lazors were doing, and doing well. Most likely, many have consulted with the Lazors about organic methods.

The Lazors make Butterworks Farm yogurt in five flavors, including a maple variety, which are available in grocery stores around the Northeast Kingdom. I get it at Currier's Market in Glover or the C&C in Barton.

Don't be afraid to try their kefir. It's a yogurt drink with a sour snap, but it's a seriously satisfying beverage and great blended with fruit as a smoothie. I thank Phil Young at the Lake Parker Country Store in West Glover for giving me the idea.

The Lazors grow their own grains for their Jersey herd and have started branching out into cultivating crops for human consumption. "We've been growing

wheat since the very beginning," says Mr. Lazor.

In 2010, the Lazors grew forty acres of wheat, fifty acres of barley and peas, one and a half acres of flax, fifty acres of soy beans, fifty to fifty-five acres of corn, in addition to rye, sunflower seed, and hay. They have about forty-five milking Jersey cows and a dozen employees.

The demand for local and organic foods has grown steadily. "People are so keen on wanting to have meaning in their food," Mr. Lazor says, "Anne is really the superstar." "I'm just the outgoing one."

Many of these methods aren't new but are rather a continuation of the way people farmed years ago. Once, Jack Lazor found a book about dairying published in 1905 that looked at the farm as an organism. "It's the kindest farming there is," he says. A lot of people see the organic rules as a list of things you can't do. He looks at them as a way to build the farm, build the soils, and sustain the plants and animals.

A new federal pasture rule for organic farmers should help Vermont, and the organic dairy industry overall. It requires cows to be on pasture 120 days a year, have a chance to get outside for exercise and fresh air every day, and take thirty percent of dry matter from grass: the same things Vermont farmers have been practicing for years, without the organic label. Well, now it's official.

at a GLANCE

Jack and Anne Lazor specialize in organic yogurt and make kefir and cheddar cheese, available at C&C Supermarket in Barton, Currier's Market in Glover, Newport Natural Foods in Newport, and many other stores in Vermont.

421 Trumpass Road
Westfield, VT 05874
(802) 744-6855
butterworksfarm@pshift.com

below: The dairy barn cupola in view from the grain tower, looking north.

previous page: Jack Lazor is outstanding in his field.

chaputs

With the number of cows Vermont has now, methane digesters won't provide enough electricity to power the state. That's why we need more cows.

Crazy talk? Crazier is the concept that we would let dairy farms go out of business without trying to help them.

Methane gases from a thousand-cow farm can produce enough electricity for about 200 homes. That means it takes five cows to make enough electricity for an average home.

Vermont is home to 142,000 cows. If all that methane were harnessed, we could make enough electricity for 28,400 homes. One-tenth of our needs—Vermont's population of about 600,000 people lives in 240,000 housing units.

Bob Montgomery, editor of *Farming: The Journal of Northeast Agriculture*, based in St. Johnsbury, traveled to Germany to take a look at farm energy there. They're way ahead of us, experimenting with recipes for the most efficient energy crops. Bob met with the Union for the Advancement of Oil and Protein Plants, which grows rape seed (also known as canola). The Germans also grow hemp, cotton, switch grass, and miscanthus, a plant that can be harvested with the same equipment as corn. All this means more options for farmers, and more ways to make farming economically sustainable. "Farmers get *paid* for manure," Mr. Montgomery said.

Vermont is ahead of the rest of the United States in taking advantage of methane digesting technology, which helps prevent air and water pollution and creates a bedding byproduct that saves the use of sawdust and money. Vermont has seven digesters (the whole United States houses about 150), and is making more energy per person from cows than any state in the Union!

But so far, only the biggest farms in Vermont have methane digesters. In Germany, they're common in hundred-cow, medium-sized farms.

Methane can be captured from landfills, too. The Washington Electric Cooperative gets seventy percent of its electricity from methane gases generated by Coventry's landfill.

Why aren't we also capturing methane from city sewer systems? Can't the technology be adapted to apply elsewhere? This is one technology that needs more investment from the state of Vermont!

above: The sign outside of Chaput Family Farms.

previous page: These Holstein cows at the Chaput farm in Newport Center give milk and generate the electricity to run the lights.

In Newport Center, the Chaput Family Farms produce about 62,300 pounds (7,245 gallons) of milk every day. Starting in August 2010, the 830 milking Holsteins and the other 970 cows on the farm have been making electricity as well—about 1.6-million kilowatt hours per year.

Reg Chaput points out that the farm's new methane digester has an additional environmental benefit: the reduction of gas emissions is equal to taking about 220 passenger cars off the road.

On the day of a celebratory open house at Chaput Family Farms, those in attendance learned that three more Vermont farmers are planning to install digesters, and the United States' Department of Agriculture will be putting $3 million into those projects for farms in Enosburg, Bridport, and Bristol.

Judith Canales, administrator of the rural business and cooperative programs of the USDA, made the trip from Washington, D.C., to make this announcement and con-gratulate the Chaputs on their efforts. She said Secretary Tom Vilsack wants to keep dairy farming alive and active.

Geoff Teigen, an environmental scientist for RCM International, the company that made the Chaputs' digester, said he's a little jealous.

"Vermont is the model that all the other states are aspiring to," he says. Mr. Teigen, who hails from California, says the systems are not as easy to sell in his home state.

"We have the happy cows out there, but you guys are lucky out here: the cows are in grass heaven."

Reg Chaput said the system cost $2 million, about half of which was covered by grants.

"It's definitely an intensive project," he says. "It took us three years to do it."

The first year was devoted to getting grants, the second year to getting permits. Then it was time to build.

A byproduct from methane digesters is bedding for cattle. Once the gases and liquids have been removed from the manure, the remaining dry matter has very little odor and is essentially clean bedding that can be reused. This saves the farmer from having to buy additional sawdust.

The Cow Power program is part of Central Vermont Public Service. Cow Power is not as cheap as other types of electricity but it has public support, including donations from customers in Vermont. Customers can opt to pay extra on monthly electricity bills, which then goes into a Cow Power fund to help build digesters. Dave Dunn of CVPS said 4,000 customers have donated $3 million since the program started.

Through the VermontSPEED program, the Chaputs have signed a twenty-year contract for power at sixteen cents per kilowatt hour.

listings

Below, and throughout the book, we've provided a detailed listing of Northern Vermont's farms, sugar shacks, arts and culture venues, festivals, and restaurants where you can experience the best the Kingdom has to offer.

Morning fog (Photo courtesy of Northwoods Stewardship Center)

ALBANY

Ploughgate Creamery
(see page 88)

ploughgate@gmail.com

AVERILL

Quimby Country
(see page 90)

Ray Wojcikewych
1127 Forest Lake Road
Averill, VT 05901
www.quimbycountry.com

BARNET

Ben's Mill Trust

Established as a nonprofit in 1999, this trust is committed to rehabilitating and maintaining the historic Ben's Mill as a piece of living history. Located on the banks of the Stevens River in Barnet.

Open from Memorial Day weekend to Columbus Day, Saturday and Sunday 11 am to 3 pm. Call Hiram Allen for tours.

P.O. Box 50
Barnet, VT 05821
(802) 748-8180
info@bensmill.com
www.bensmill.com

Joe's Brook Farm

A full spectrum of organic vegetables, specializing in early tomatoes and strawberries. Find their produce and maple syrup at Danville, Lyndonville, Littleton, and St. Johnsbury farmers' markets, where you can also sign up for their CSA program.

Open June to October.

1525 Joe's Brook Road
Barnet, VT 05819
(802) 473-6074
mskovsted@gmail.com
www.joesbrookfarm.com

Karme Choling Mediation Center VF

The oldest Shambhala Buddhist center in North America and Europe, the Karme Choling hosts meditation retreats, study seminars, and training programs.

369 Pateneaude Lane
Barnet, VT 05821
(802) 633-2384
reception@karmecholing.org
www.karmecholing.org

Koren and William Warden

This husband and wife duo sell chicken, beef, eggs, vegetables, and maple products both directly and at farmers' markets.

802 Warden Road
Barnet, VT 05819
(802) 633-4959
Kww802@yahoo.com

Little Way Farm

Raises and sells vegetables, flowers, and maple syrup.

900 Bony Woods Road
Barnet, VT 05821
(802) 274-6097

Magnus Wool

Marylin Magnus sells homemade rugs and handspun yarn she cultivates from her flock of cross-bred Cotswold-Border Leicester sheep in both natural and hand-dyed colors. You can find her products online at her Etsy shop and at fiber festivals throughout the Northeast.

2888 E. Peacham Road
Barnet, VT 05821
(802) 592-3320
magnuswools@fairpoint.net
www.magnuswools.com

Too Little Farm

(see page 104)

Elizabeth Everts
278 Cloudy Pasture Lane
Barnet, VT 05821
(802) 592-3088

BARTON

Crystal Lake Falls and Brick Kingdom Museum

This historic site and museum located along Water Street was once a cluster of mills that manufactured piano works, furniture, and ladies' cotton lingerie. It dates back to the 1790s. All of the manufacturers used hydro power from the Crystal Lake outlet.

John Brown, Curator
97 Water Street
P.O. Box 253
Barton, VT 05822
(802) 525-3703

Cranberry and orange cake from Bien Fait Bakery (see p. 85)

jfbrown259@myfairpoint.net

Crystal Lake State Park

Set by the beautiful glacial Lake Crystal, this park enjoys a mile of sandy beach with a swimming area, forty free-standing charcoal grills, kayak and canoe rentals, and a small cottage for lodging.

Open Memorial Day weekend to Labor Day weekend 10 am to 9 pm (or sunset).

96 Bellwater Avenue
Barton, VT 05822
Toll-free: (800) 658-6934
Summer: (802) 525-6205
Winter: (802) 479-4280

Farm and Forest Ranch

(see p. 46)

Dan Maclure
2867 Maple Hill Road
Barton, VT 05822
(802) 754-2263

Four Acre Farm

A farm and store with local produce and baked goods, maple syrup, medicinal herbs, cedar yard furniture, plants, and artwork. The owners plan to hold events on site with Uncle Meats

barbecue. Off Interstate 91 at the Barton exit.

Cavan Meese, General Manager
Ben Barnes, Retail Manager
776 Glover Road (Route 16)
Barton, Vermont 05822
(802) 525-5515

Gus' 12K Granola

12K Granola is now made in Barton by Amy Braun, who bought the company from Lois Barrows of Glover. Mrs. Barrows started making granola ten years ago while working at Currier's Market, whose owner was running marathons (hence the name 12K). It is available at Currier's, Ray's Market in Irasburg, Newport Natural Foods, Hall's Market in Hardwick, and the White Market in Lyndonville and St. Johnsbury.

16 Church Street
PO Box 578
Barton, VT 05822
(802) 525-3044
gus12@granola@fairpoint.net

Orleans County Fair

(see page 78)

278 Roaring Brook Road
Barton, VT 05822
(802) 525-3555
www.orleanscountyfair.com

continued on page 34

claire's restaurant

The sunflower sprouts at Claire's Restaurant in Hardwick are amazing atop crispy filone bread smothered with Coomersdale cheese, caramelized onions, apples, and a creamy nutmeg sauce.

Wow, sunflower sprouts taste like a blast of sunshine. The rest of the cooking at Claire's is also awesome comfort food.

Back in 2003, Linda Ramsdell, owner of The Galaxy Bookshop in Hardwick, started thinking about how wonderful it would be to have a restaurant in Hardwick that served locally produced food. She and a few others decided to hold a meeting to see if people in town were interested.

Fifty-five people showed up. This was their first clue that a place like Claire's would be well-received.

Ms. Ramsdell heard about a restaurant in Bristol called the Bobcat Café that operated by a community-supported model: they asked for financial help from potential patrons in much the same way that community-supported agriculture allows consumers to sign up for a pre-paid subscription guaranteeing a weekly allotment of food.

People in the Hardwick area were definitely interested in this type of establishment, and some were willing to invest.

Ms. Ramsdell credits Paul Bruhn of the Preservation Trust of Vermont for coming up with a financial plan that allowed more than one level of investment. One group invested in the real estate while a second group owned the restaurant business. Ms. Ramsdell is the one person who can claims to be part owner of both.

Claire's opened in a space on Main Street that originally housed Benny's Bar, which burned down and was later replaced by a used clothing store. The restaurant was named in memory of Claire Fern, artist, gardener, educator, social activist, cook extraordinaire, and one of Hardwick's most beloved residents. "She brought great people and great food together in her home," says Ms. Ramsdell.

The local food movement in Hardwick grew as the restaurant did, with cheesemakers, soy producers, several vegetable growers, a seed company, and a compost company included among the active businesses within a few miles of the café. "What Claire's provides is kind of a showcase for what everybody's doing," co-owner Mike Bosia says.

The restaurant's top priority is to use produce from local farms to make its dishes. Every single day, the restaurant's chef and proprietor, Steven Obranovich, calls area farmers—or they call him—so he can plan the menu. For two weeks there might be an abundance of dishes with rhubarb, and the next week, none. Another week the menu will be chock full of fava beans, which will vanish as quickly as they came. In the winter, there are lots of turnips.

"Over seventy-nine cents of every dollar goes into local farms," says Mr. Bosia. By local he means farms within fifteen miles. The restaurant spends some of the remaining twenty-one cents on other Vermont products, but if the goods come from farther than fifteen miles away they don't count toward Claire's mission.

"It's just fascinating to watch this. I've never seen anything like it," says Mr. Bosia.

Mr. Obranovich sources all the ingredients on a small, local level; he even learned how to forage for fresh ramps (also known as wild leeks) and fiddleheads himself.

"There's no big truck pulling up. There are pickups and Subarus that pull up with boxes of food," Mr. Bosia says. The food comes from twenty-five farms within fifteen miles, taken "right out of the ground, right out of the chicken, right out of the slaughterhouse." One morning he arrived at Claire's restaurant to find garlic scapes on the door that someone had left. "We had to make this rule that they couldn't call at home until eight am."

at a GLANCE

Chef and proprietor Steven Obranovich spends over seventy-nine cents of every dollar on food grown and produced within fifteen miles of Hardwick.

41 South Main Street
Hardwick, VT 05843
(802) 472-7053
newvermontcooking@yahoo.com

Together for twenty years, Mr. Bosia and Mr. Obranovich recently made their relationship official and got married— at Claire's.

Ms. Ramsdell said that one winter night she took a friend to dinner at Claire's who ordered a plain green salad that wasn't on the menu. Instead, Ms. Ramsdell's friend tried a beet salad. She ended up loving it. Sometimes it's hard for people to understand that things they are used to ordering at most restaurants might not be available on any given day at Claire's. But that's the fun part and clearly, people are into it.

On a Tuesday evening in November, the restaurant was full by 5:30 pm. Most nights it's a good idea to get a reservation.

From the beginning, Ms. Ramsdell says, "the response was completely overwhelming."

left: Sunflower sprouts top this crispy filone bread, along with bacon, onions, apples, and cheese.

previous page: Chef Steven Obranovich serves up local food at Claire's.

couture's

Agriculture and tourism have always gone together. People come to Vermont to see the beautiful working landscape and taste the fresh eggs, strawberries, corn on the cob, cheese, and milk.

What do farmers need in order to make agritourism work for them? This is a core question that has been posed by the Northeast Kingdom Travel and Tourism Association. Director Gloria Bruce tries to figure out how to make good connections that will provide an authentic and pleasant farm experience for tourists, while helping farmers economically.

At meetings on the subject, I have heard farmers say they would love to have tourists visit, but have some practical problems, such as a lack of public bathrooms, as an impediment. Others say they don't want do the marketing for tours themselves, but that they might take advantage of group marketing activities such as a community website.

Bill Schomburg mentioned at one of these meetings that he made a connection with the Balsams Grand Hotel in Dixville Notch, a relationship that has helped his Christmas tree farm tremendously. Visitors come to stay at the Balsams' and get a tour of the tree farm. Each visitor has the option to pick out a tree and put a ribbon on it to reserve it for the Christmas season. That tree will then be shipped to the visitor to enjoy when yuletide rolls around.

"Agritourism is on fire in terms of publicity," Gloria Bruce says. "The demand has risen exponentially." Farmers can take advantage of tourists' desires to visit their locations and try their products. However, there are potential issues with farm visits, such as the safety hazards of a five-year-old city visitor unknowingly touching an electric fence. Farmers who truly want to host tourists have to think about their facilities in a different way, Ms. Bruce says.

Jacques and Pauline Couture of Westfield (just fifteen minutes from Jay Peak) opened their home to tourists in 2002. The farm operates as a dairy, a maple sugaring manufacturer, and a bed and breakfast.

The Coutures have been dairy farming for forty years. They both grew up in families that tapped maple trees to make syrup, so it's no surprise

that the sugaring part of their operation came easily. In 2007 they began producing organic milk, which meant a nice increase in revenue. Organic farmers often receive twice as much per gallon as farmers who ship to the non-organic market.

"It was harder in my head than in reality," Mr. Couture says about the changeover. Farming organically means he can't use certain medications that he relied on in the past, including antibiotics, but he's used to organic methods and finds they work well.

This year, the Coutures rebuilt their barnyard and manure system to capture all the runoff. "We've got almost a zero pollution system here," says Mr. Couture proudly. On their wet land, it was not an easy feat.

The Coutures' farm is 325 acres, situated on the main road in Westfield. Their first effort at agritourism was putting up a small sign that said they had maple syrup and candy for sale.

In 1989 they were approached by a local entrepreneur, Tim Palmer-Benson, whose words Mr. Couture remembers. "'I'd really like to

have you have a website.' And I said, 'What's that?' We weren't even online yet, but we had a website!"

Mr. Palmer-Benson faxed them orders that came in on their website, and the first year they broke even on the $700 annual cost. Before many more years went by, they began to reap the monetary benefits of their website, which today constitutes a large part of their sales. They are even able to offer free Wi-Fi to customers.

The Coutures have six grown children, five of whom are married. They have two grandchildren who live in town, ages five and seven, who love to visit their grandparents and run to the barn to try to find freshly-laid chicken eggs.

In 2002 they decided to open their home, built in 1892, as a bed and breakfast. Since then the Coutures have enjoyed that part of their farm's operation. They have hosted visitors from as far away as Australia and Ukraine, including a couple from India, and regulars who come back every year from Montreal. (It doesn't hurt that the Coutures are fluent in

French.) One visitor they had was a seventy-year-old single woman from the Bronx in New York. She rode in on her motorcycle, en route to a Harley-Davidson rally in Sherbrooke, Quebec. Mr. Couture tried to help her with her bags. She said "No, thank you."

"You'd be amazed how many times we bring our atlas out to the breakfast table," says Mr. Couture about his now-global business, as Mrs. Couture looked through some recipes. One in particular catches her eye—sweet potato whoopie pies.

at a GLANCE

Couture's Maple Shop and Bed and Breakfast

560 VT Route 100
Westfield, VT 05874
(802) 744-2733
Toll-free (800) 845-2733
Open 8 am to 5 pm daily

www.maplesyrupvermont.com

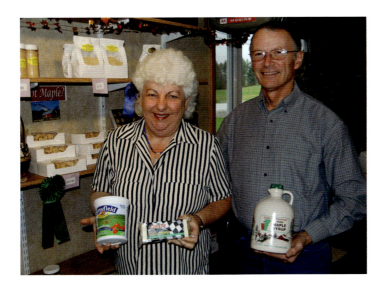

left: Most of the Coutures' milk goes into Stonyfield yogurt, but some goes to make Cabot cheeses. They also make and sell maple products.

previous page: The Coutures' home, built in 1892.

deep mountain maple

The Northeast Kingdom was proudly represented by a cheesemaker and a maple producer at the Slow Food festival and conference in Italy in October of 2010.

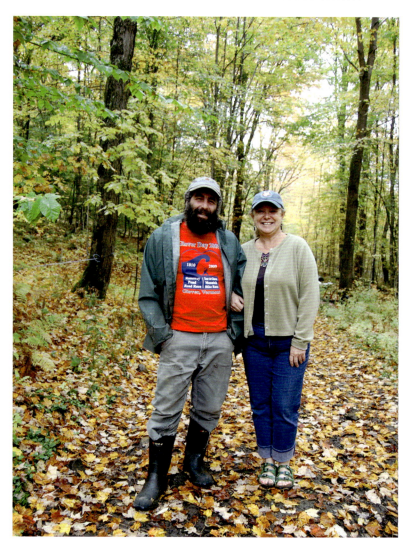

Marisa Mauro of Ploughgate Cheese in Albany and Howie and Stephan Cantor of Deep Mountain Maple in West Glover served as delegates.

Upon their return, Ms. Cantor said the experience was amazing and overwhelming, and it affirmed what she had been thinking about food for a very long time.

The theme of the conference was indigenous foods and what we can learn from them, a subject that she and her husband have spent a lot of time thinking about while boiling maple sap down to syrup in their sugarhouse.

The Cantors boil sap by burning wood from the trees in their sugarbush. For them, it's a perfect environmental cycle and a simple way to do it, but they also believe their methods and the specific place where their product comes from make a difference in its flavor and quality—the "*terroir.*"

It's a word and concept winemakers have discussed for years—the idea that grapes grown in a particular spot in France or California create a particular flavor of wine.

Maple is possibly the slowest food of all, as sap must be boiled for hours to get the syrup.

The Slow Food conference is called Terra Madre and is held every other year. In 2010, it was hosted in Torino, Italy.

"Slow Food is an idea, a way of living and a way of eating. It is a global, grassroots led movement with thousands of members around the world that links the pleasure of food with a commitment to community and the environment," says the Slow Food USA website.

Participants had the opportunity of attending a wide range of events and trying a great variety of wines, cheeses, breads, vegetables, and more. They sampled sixteen-year-old cheese paired with rhododen-

dron honey, bread from Iceland cooked in the steam of geysers, and Scotch whiskey distilled in 1960. Workshops included "Capital, Regulations, and Distribution: Issues and Prospects for a New Agriculture" and "Quality at the Right Price."

"What it tries to do is bring together small food producers," says Ms. Cantor. Farmers, chefs, and food writers attend the conference, among others.

"I'm so proud to represent the Northeast Kingdom," said Ms. Cantor before the trip. "We're completely honored."

Mr. and Ms. Cantor were nominated and attended the conference as delegates (where they also served as mentors to a group of younger farmers) by the Greenmarket in New York—a network of markets in the city where 150 or so farmers sell their wares, and where the Cantors have sold their products for twenty-five years.

The Cantors sell their goods at the Union Square Greenmarket in Manhattan. Before 9/11, they sold at the World Trade Center. The maple candy varieties the Cantors have offered are flavored with pecans, ginger, and hot peppers. Consumers in New York gravitate to their products, the Cantors say, because they are made in Vermont. "They just assume it's better," says Mr. Cantor.

He mentions that he is making syrup from the same sugarbush on his property that has been producing maple syrup for close to 100 years, and in very much the same way. However, the Cantors did switch from collecting sap in buckets to using plastic tubing and a vacuum, which saves time but seems to have done no harm to the flavor.

They both say everyone who makes food has to weigh

the advantages of certain methods in terms of cost, volume of product, and quality. "You can choose some technologies and not choose others, and then you can change your mind," he says.

Howie Cantor is not only a maple producer, he is also a folk singer and songwriter who performs with Bread and Puppet Theater. One day, he was stopped at the Canadian border with explosives in his trunk that he planned to use in a performance. He was coming home from playing ice hockey in Stanstead, Canada with a group of friends who play regularly. Howie had completely forgotten he had the dynamite in his car, and had to do some fast talking when the Border Patrol officer opened the trunk and found the explosives.

You might get Howie to tell you the story in person one Thursday night at Parker Pie, where he organizes weekly music nights.

at a GLANCE

Deep Mountain maple products are available at the Cantors' home and sugarbush, but they suggest visitors call ahead. Deep Mountain maple syrup and granulated maple sugar are available at the Lake Parker Country Store in West Glover, Vermont and at the Greenmarket in Union Square in New York City.

*P.O. Box 68
West Glover, VT 05875
(802) 525-4162
info@DeepMountainMaple.com*

below: Deep Mountain maple syrup is for sale at the Lake Parker Country Store in West Glover, located in the same building as Parker Pie. The mug is made by Sarah Russell.

previous page: Howie and Stephan Cantor were excited and proud to represent the Northeast Kingdom at the 2010 Slow Food conference in Italy. This photo was taken in their sugarbush in West Glover.

BIKING THE KINGDOM

Whether you're a casual cruiser or a hard-core trail enthusiast, the Kingdom provides visitors with a true cycling heaven. Quiet back roads, cool swimming holes, sweeping panoramas, glacial lakes, and verdant expanses await both day-trippers and week-long vacationers. For a comprehensive and carefully mapped guide to the Kingdom's bike loops, visit the Northeastern Vermont Development Association (NVDA) website at www.nvda.net. The Northeast Kingdom Travel and Tourism Association offers printed maps at www.travelthekingdom.com or (1-800) 884-8001. For those who prefer the rigor and reward of mountain biking, Kingdom Trails (www.kingdomtrails.org) maps 100 miles of moderate to difficult bike trails voted by *National Geographic Adventure Magazine* as "the best mountain-bike terrain east of the Mississippi."*

From http://www.nvda.net/Transp/bikeped.html

Peak View Farm Stand
(see page 82)

Route 5
Barton, VT 05822
(802) 754-6319

Sugar Maple Farm and Maple Museum

Produces and sells pure, organic Vermont maple syrup, maple candy, and maple everything. They offer tours of the farms, sugaring house, and maple orchards.

Route 16
Barton VT 05822
Toll-free: (800) 688-7978
(802) 525-3701
vtmaple@myfairpoint.net

Taylor's Automotive
(see page 98)

Francis and Helene Taylor
Route 16
Barton, VT 05822

BROWNINGTON

Clan of the Hawk

A large, active group of Abenaki Native Americans who have gathered for over twenty years to conduct pow-wows and ceremonies. There are several buildings on the site, including a museum and a chapel that are open to the public. They hold naming ceremonies, weddings, funerals, spiritual gatherings, and pot luck suppers on the land.

123 Evansville Road
Browington, VT 05860
(802) 754-2817
etpvt@aol.com
www.clanofthehawkinc.org

Neal Perry Farm

A true horse whisperer, Neal Perry uses unique training techniques to bring horse and rider closer to one another. The farm offers an array of equestrian services including training, clinics, and lessons in both English and Western riding schools. Sleigh rides are available in winter. Call ahead to book.

Neal Perry
509 Dutton Brook Road
Brownington, VT 05860
(802) 754-2396
neal@nealperryfarm.com
www.nealperryfarm.com

The Old Stone House

Established by Alexander Twilight, the nation's first African American college graduate, this museum in the picture-perfect Vermont hamlet celebrates nineteenth century life in Northern Vermont. It offers lively classes in beekeeping, blacksmithing, cordial-making, knitting, and hosts wonderful farm-to-table dinners and much more. Old Stone House Day in mid-August is a can't miss. It sells a variety of goods including rhubarb, mushrooms, apples, cheeses, and fresh juice.

109 Old Stone House Road
Brownington, VT 05860
www.oldstonehousemuseum.org

BRUNSWICK

Silvio O. Conte National Fish and Wildlife Refuge

The refuge features exhibits illustrating the natural and cultural history of the surrounding area as well as scenic attractions including the Nulhegan River trail, the Mollie Beattie bog, and Lewis Pond. Visitors can take advantage of the superb birding,

hunting, and fishing along the Nulhegan's several branches.

The Contact Station is open daily from 8 am to 4:30 pm.

Mark Maghini
5396 Route 105
Brunswick, VT 05905
(802) 962-5240 x 112
mark_maghini@fws.gov
www.fws.gov/r5soc/come_visit/
nulhegan_basin_division.html

CABOT

Cabot Creamery

Since 1919, Cabot Creamery has crafted award-winning cheddars, and today is made up of a 1,200 farm family-owned dairy cooperative with members in New England and upstate New York. The Visitors' Center offers a factory tour, free samples, and a history of the creamery and Vermont agriculture.

2878 Main Street
Cabot, VT 05647
Toll-free: (800) 837-4261
vctr@cabotcheese.com
www.vermontagriculture.com

American Society of Dowsers (Photo courtesy of the American Society of Dowsers)

CALAIS

Cedar Brook Farm

A model of sustainable family farming, Anthony Palmiero and his family raise potatoes, corn, eggs, poultry, and pork. Mr. Palmiero has been growing hops for twenty years to make beer for himself, and has recently moved his farm from East Hardwick to Calais in order to develop his commerical hops growing business. He is a member of the New England Hops Alliance and the Vermont Hops Growers Association. Call ahead for a visit.

Physical address:

121 Still Brook Road
Calais, VT 05666

Mailing address:
121 Still Brook Road
North Montpelier, VT 05666
(802) 456-1436
ajpalmiero@vtlink.net

CANAAN

Alice M. Ward Memorial Library

Affiliated with the library system serving Canaan, Vermont, this collection contains over 10,877 volumes.

27 Park Street
Canaan, VT 05903
(802) 266-7135

Baum Farm

A certified organic farm that produces raw milk, free-range eggs, and hay. At Baum you can take a farm tour and pet their docile Jersey cows. Baum is the only farm in Vermont approved by Animal Welfare.

Eli Petit writes in his journal in a sunflower house at the Coventry Village School Garden of Life. (Photo courtesy of Green Mountain Farm-to-School)

continued on page 42

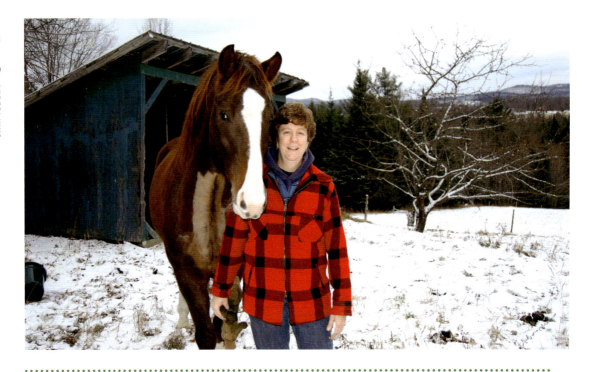

echo hill

Louise Calderwood gets stuff done. I was not surprised to hear that she had been hired as Interim Project Manager for the Vermont Food Venture Center in Hardwick.

The buzz around Hardwick has at times seemed loud and vague, but the Venture Center is a concrete example of a project that can generate momentum for the local food economy.

The Venture Center was conceived as a food business incubator building. "The purpose is to give businesses in Vermont an opportunity to add value to agricultural products," says Ms. Calderwood.

The center moved to Hardwick from Fairfax, where it outgrew its space. The new 15,000-square-foot facility will have five production cells and a warehouse. The cells will accommodate a meat processor and a dairy processor, each on

a five-year lease, plus a cell for packing wet products such as salsas and jams, a bakery, and a cell for vegetables and dry mixes. People who want to use the cells for wet products, vegetables, baking, and dry mixes can rent space for much shorter time periods, even by the hour or the day.

"Right now what we're seeing is a lot of interest at the school level," Ms. Calderwood says. Schools are interested in buying local vegetables in bulk that have been processed to some extent—for example, carrots that are cut up and frozen in large packages.

The Venture Center will be owned by the Center for an Ag-

ricultural Economy and has a steering committee headed by Tom Stearns of High Mowing Farm in Wolcott, Andrew Meyer of Vermont Soy in Hardwick, Andy Kehler of the Cellars at Jasper Hill in Greensboro, and Neil Urie of Bonnieview Farm in Albany.

"I recognize that neither the meat cell nor the dairy cell are going to meet the needs of everybody," says Ms. Calderwood, who plans to step down once the facility is up and running. "We already see that the needs are broader than the existing facility."

The Cellars at Jasper Hill will occupy the dairy cell. The company committed itself to

at a GLANCE

*Louise and Randi
Calderwood and sons*

*440 Echo Hill Road
Craftsbury, VT 05826
(802) 586-2239
rcalderwood@aol.com*

left: Louise, Doug, Andrew, and Randi Calderwood and their dog, Logan, stand in front of the new Echo Hill Farm sugarhouse.

previous page: Louise Calderwood rides and drives her horse, and enters him in driving competitions.

a long-term lease two years before construction.

Milk from one farm will go to the Center, where it will be made into Jasper Hill cheese by intern cheesemakers.

Funding for the project was provided by the United States Department of Agriculture, the Economic Development Administration, and state Community Development Block Grant funds.

People with small business proposals who are interested in starting a new product can take advantage of business planning help at the Center for an Agricultural Economy offered by Heidi Krantz.

Ms. Calderwood was a University of Vermont Extension agent for ten years and Deputy Secretary of Agriculture for Vermont for eight years before starting her own business as an agricultural consultant. She works in government relations and product development, in addition to her work with grant-writing and education.

"While I am still totally committed to the future of dairy farming, I'm also totally

aware of the other opportunities," she says.

The center is planning to hire an executive director, an operations manager, and a facilities manager.

The Calderwood family is in the middle of a building project as well. Echo Hill Farm is a maple syrup and maple cream producer. Ms. Calderwood, her husband (and former dairy farmer) Randi, and their sons are building a new sugarhouse.

Randi's great-grandfather, Robert Calderwood, started the family's maple business on a different site in Craftsbury. The Calderwoods then moved to their farm to East Craftsbury in the early 1970s. When they got out of the dairy business, they moved their farmhouse up the hill and off South Albany Road.

Randi and Louise's sons, Doug and Andrew, represent the fifth generation of maple producers in the Calderwood family.

Randi says he'd like to expand the operation to have about 6,000 maple taps. His mother, Fielda, sells the syrup at the Craftsbury and Hardwick farmers' markets.

When she is not developing agricultural businesses, Louise Calderwood likes trail riding and competitive driving with her horse.

eden ice cider

Not everyone loves Eden Ice Cider. When Eleanor and Albert Leger of Charleston brought samples around to twenty-seven restaurants to see if they would be interested, only twenty-six of them bought it.

Ice cider is somehow sweet and tart at the same time; it's crisp, fresh, fierce, but refined and civilized. It's powerful but not overwhelming at eleven percent alcohol. It's complicated, in a good way.

Albert Leger is French Canadian, and the Legers first tried ice cider in Montreal. The process of making ice cider begins in the same way as does traditional cider, where the juice is squeezed out of apples. Then, it is frozen. The frozen cider is allowed to thaw partially, at which point the ice is taken out, leaving an apple concentrate that is then fermented, filtered, and made into wine.

Eleanor Leger is a business and financial management consultant with roots that go way back in Vermont. Née Ufford, her grandfather, had a buggy factory in Barton. "There's one in the museum at the Old Stone House," she says.

Her husband is a chemistry teacher. The two have lived in many places, mostly in New York, but they always hoped to get back to Vermont.

An opportunity to return presented itself in the form of an abandoned 150-acre dairy farm in Charleston that they bought in 2007. The first year they planted 375 trees. Now they have 1,100.

The trees are not yet producing apples; however, this gave the Legers the chance to meet growers with heirloom varieties (like Zeke Goodband, an apple grower on Rudyard Kipling's estate in Brattleboro, and Bill Suhr of Champlain Orchards in Shoreham) who provided the Legers with their first apples.

"We have thirty-two varieties," Ms. Leger says. If things go

well, the farm will have its first good crop in Fall 2011.

So far, so good. The first year they made 100 cases of ice cider. Last year they made 1,200 cases.

In order to create a blend that would make a perfect ice cider recipe, the first batches were made out of individual varieties, then blended. The Legers invited two oenologists—wine specialists—from Montreal to help with the process.

At this point they are already outgrowing their small facility, which gave Ms. Leger another idea. What if there was

at a GLANCE

Eden Ice Cider is available at Newport Natural Foods, the general store in Charleston, the St. Johnsbury Farmers' Market, and sometimes at the farm after calling ahead.

*1023 Sanderson Hill Road
West Charleston, VT 05872
(802) 895-2838
contact@edenicecider.com*

a retail center that could be shared by people who make ice cider, cheese, and bread?

The fact is, farmers and food producers sometimes don't have time to talk to visitors at the farm who might want to buy their products. "That's a missed opportunity," Ms. Leger says. "A tasting center could help solve that problem."

Ms. Leger is working with the Northeast Kingdom Travel and Tourism Association to renovate space in Newport to create the Northeast Kingdom Tasting Center for just this purpose.

above: These Calville Blanc apples wait in cases until the time is right to make ice cider. The process starts in the winter.

right: Eden Ice Cider comes in tall, thin bottles. It is filtered and has a golden glow.

previous page: Eleanor Leger holds some of the apple varieties she uses to make Eden ice cider. On the left are Rhode Island Greening (the green one), Esopus Spitzenburg, and Roxbury Russet (the small one). On the right are Calville Blanc (the yellow one), Northern Spy (the large one), and Hudson's Gem.

emergo

Here's a formula for perfect skiing conditions: six inches of snow accumulated on the ground, then thaw—which creates a hard crust—topped by another inch of snow.

Sometimes, it's so cold you hear a tree snap loudly from freezing. At those moments, things are deeply quiet. You can hear only the sound of skis, and sometimes a raven—the only bird I see or hear much of in the winter except the cheerful little chickadee. The raven's deep croaky calls echoe in all that cold quiet.

Emergo Farm in Danville is a working dairy farm and bed and breakfast that boasts its own ski trails. Lori Webster tells me she doesn't get a lot of business in the winter, which surprises me. The hills around the spectacular old barn at

Emergo look like they'd be a blast to ski on. Plus, it's not far from Burke. She even has a kind of apartment with a full kitchen upstairs in the huge old farmhouse. Instead, more people come in the summer to see what life is like on a working dairy farm.

Ms. Webster's husband's great-grandfather bought Emergo Farm in 1858.

"[Emergo] is a Latin word, and it means 'to rise,'" she says. Her theory is that the farm was named that way due to the lay of the land. But the word works as a metaphor, too. A farm gets started each day when the sun

rises; the seeds rise into plants during the growing season.

"It's always been a dairy farm," Lori says. The family started with fifteen Jersey cows, and these days they milk one hundred. It's one of just two working dairy farms left in Danville. The Websters sell their milk to the Cabot Creamery.

The couple's adult son, Justin, works alongside them on the farm and represents the sixth generation of Websters to work the land.

Ms. Webster says she enjoys the bed and breakfast guests,

at a GLANCE

*Emergo Farm and
Bed and Breakfast*

*261 Webster Hill
Danville, VT 05828*
(802) 684-2215
emergo@together.net

left: This is the way dairy farmers used to take milk to the Cabot Farmers Cooperative Creamery—in milk cans in the back of a buggy pulled by a horse. A visit to Emergo Farm is a chance to see Vermont farm history by way of the farm's heritage tour.

left, below: Holstein heifers at Emergo Farm.

previous page: Lori and Bebo Webster at their bed and breakfast on their working dairy farm.

some of whom come back each year for another visit.

One day, she came to the front porch to find a couple who wanted a room, surrounded by her goats who had escaped from their pen. Ms. Webster apologized profusely, but the couple didn't mind. "He just loved those goats," she says. The couple were professionals, one a lawyer and one a professor, and have returned every year. They love the area so much they wound up buying property—and getting some goats for themselves! (They ended up selling that property later, however. Maybe someday

they'll return as customers to the bed and breakfast).

The Websters get up every morning at about 5 or 5:30 am, and if the guests want to, they can join them at the barn to see how milking and the rest of the chores are done—all before breakfast. More often, they come to the barn for evening chores, instead. Either way, it's the real thing.

Angus beef cattle are grazing on a pasture in the Northeast Kingdom.

Baum Farm

(continued from page 35)

409 VT Route 102
Canaan, VT 05903
(802) 673-8625
sales@baumfarm.com

Canaan Moose Festival

Local artisans and craftspeople fill the booths with handmade products and edible delights at this festival, whose highlights include helicopter rides, a classic car show, and a moose stew contest. Live music and children's games round out the entertainment. This year marks the twentieth anniversary of the festival.

Usually runs August 26 to 28.

P.O. Box 1
Colebrook, NH 03576
(603) 237-8939
nccoc@myfairpoint.net
www.northcountrychamber.org

CORINTH

Blythedale Farm

This amazing dairy run by Tom and Becky Loftus hand-ladles all of their cheeses, using only whole milk to make several varieties including Vermont Brie, Camembert Vermont, Green Mountain Gruyere, and Jersey Blue.

Tom and Becky Loftus
1471 Cookeville Road
Corinth, VT 05039
(802) 439-6575
blythedalefarm@valley.net

CRAFTSBURY

Bonnieview Farm

(see page 20)

2228 South Albany Road
Craftsbury Common, VT 05827
bonniecheese@gmail.com
(802) 755-6878
www.ewemilk.com

Brown's Beautiful Blueberries

Pick your own!

Open daily from 8 am to 6 pm seasonally, beginning July 15.

Phil Lovely
493 Colburn Hill Road
Craftsbury, VT 05826
(802) 586-2843
brownlovely@myfairpoint.net

The Craftsbury Inn

A charming inn built in Greek revivalist style circa 1850. They offer ten rooms, French-inspired cuisine, and libations in their wood paneled pub.

Bill and Kathy Maire
107 Craftsbury Road
Craftsbury, VT 05826
(802) 586-2848
(800) 336-2848
cburyinn@together.net

Echo Hill Farm

(see page 36)

Louise and Randi Calderwood
440 Echo Hill Road
Craftsbury, VT 05826
(802) 586-2239
rcalderwood@aol.com

Cow Palace restaurant in Derby, Vermont

CANAAN CORINTH CRAFTSBURY CRAFTSBURY COMMON

Four Winds Farm
(see page 48)

Mark Dunbar and Tule Fogg
Ketchum Hill Road
Craftsbury, VT 05826
(802) 586-2571

Mountain Road Farm

From their herd of 175 goats,
Mountain Road provides milk
for Vermont Butter and Cheese
products.

387 Eden Mountain Road
Craftsbury, VT 05826
(802) 586-2857

Pete's Greens
(see page 86)

266 S. Craftsbury Road
Craftsbury, VT 05826
(802) 586-2882
tim@petersgreens.com
amy@petesgreens.com
www.petesgreens.com

Stardust Books and Café

Offers outstanding coffee and
espresso in a cozy atmosphere.
They sell new and used books
and provide free Wi-Fi, readings,
poetry jams, and live music. The
café's sister-storefront, The Art
House, is located just down the
street and displays fine art by
local artists. Both locations pro-
mote locally crafted goods.

Open Monday through Friday
7:30 am to 4 pm, and Saturdays
10 am to 2 pm.

1376 N. Craftsbury Road
Craftsbury, VT 05827
(802) 586-2200
stardust.independent@gmail.com
www.stardustindependent.com

TOWN & COUNTRY

Voted "Best Small Town" in 2006 by *National Geographic Adventure's* "Where to Live and Play," St. Johnsbury gracefully balances old culture and new ideas. Settled in the crux of the Passumpsic, Moose, and Sleepers rivers, this gem of a town boasts year-round adventure. Whether catching a first-run film or live jazz concert at Catamount Arts, tasting the liquid gold that proves the city's nick-name, "Maple Center of the World," stumbling upon a county fair, farmers' market, or antique car rally, or simply strolling along its authentic Victorian Main Street, St. Johnsbury exudes old world charm. In perfect harmony with the surrounding countryside of farmland and wood-land, this small town is a must-stop.

From http://www.discoverstjvt.com/about_st_j.php

Wild Branch Valley Farms

This farm grows wild mushrooms
along with a large variety of
vegetables, flowers, and grass-
fed beef, all certified organic.
Products are available for sale
at the Wild Branch farm stand
and at their booths at the Stowe
and Craftsbury farmers' markets.
Open to the public.

Kris and Glenn Coville
1748 Wild Branch Road
Craftsbury, VT 05826
(802) 586-8022
glenncoville@gmail.com

The Writer's Retreat

Award-winning author and
subsistence farmer Julia Shipley
rents out a studio apartment
on her farm called the Writer's
Retreat, part of an international
network. She raises her own ani-
mals, cultivates vegetables and
flowers, and sells pumpkins and
homemade goodies.

Julia Shipley
P.O. Box 29
Craftsbury, VT 05826
(802) 586-7733
jshipley@pshift.com
www.writingonthefarm.com

CRAFTSBURY COMMON

Craftsbury Outdoor Center

This nationally renowned athletic
center offers year-round intensive
training for numerous sports,
including Nordic skiing, running,
and sculling. On-site Craftsbury-
accommodations boast spectacu-
lar trails that weave around lakes
and through meadows and forest.

continued on page 52

farmers' markets

Curtis Sjolander and Elizabeth Everts manage the Caledonia Farmers' Market group. They have seen a lot of growth.

"Each one of us does better than we ever would alone," Mr. Sjolander says. He sells trout and vegetables, including bright purple, pink, and yellow potatoes. His farm is Mountain Foot in South Wheelock.

Mr. Sjolander says that despite the fact there are more farmers' markets around than there were in the past, the Caledonia market (St. Johnsbury and Danville) has fifty vendors and is approaching a gross annual sales figure of $350,000. It has been increasing by ten percent a year.

The summer farmers' markets have done well enough that a regular winter market now runs once a month. In the winter, the market is held on the first Saturday of each month in the Welcome Center at the old railroad station in St. Johnsbury from 10 am to 1 pm.

"This is only our second year with a winter market," says Ms. Everts, who runs Too Little Farm in Barnet. She notes that shopping at the farmers' market is a social event. "[Customers] can get a nice sticky bun and shop with their mouths full."

This year marks the second winter for the Craftsbury Winter Farmers' Market, as well, which is held monthly.

In the summer, you can find farmers' markets in the following places:

» **Barton Village Market, in the parking lot of the Barton Public Library**
Saturday 9 am to 2 pm
Khristopher Flack
bartonvillagemarket@gmail.com

» **Danville, on the green**
Wednesdays 9 am to 1 pm
Elizabeth Everts
(802) 592-3088

» **Groton, at Veteran Memorial Park**
Saturdays 9 am to 12 noon
Mary Berlejung
(802) 584-3595
grotongrowers@gmail.com

» **Hardwick, on Route 15**
Fridays 3 pm to 6 pm

left: Louis Pulver of Surfing Veggies in East Hardwick sells veggies and eggs at the Craftsbury Winter Farmers' Market.

previous page: Customers at the St. Johnsbury Winter Farmers' Market are greeted by a huge wooden dog, the work of the late artist Stephen Huneck. Mr. Huneck built a Dog Chapel to celebrate the spiritual bond between people and dogs at Dog Mountain Farm in St. Johnsbury.

Megan Toaldo
(802) 533-2337
hardwickfarmersmarket@
gmail.com

» **Lyndonville,
at Bandstand Park**
Fridays 3 to 7 pm
Brian Titus
(802) 533-7455
info@woodsedgefarm.org
www.lyndonfarmersmarket.
com

» **Peacham, at Peacham Corners across from the library**
Thursdays 3 pm to 6 pm
Madge Rossinnoff
(802) 592-3370
www.peacham.net/farmers-
market

» **St. Johnsbury,
on Pearl Street**
Saturdays 9 am to 1 pm
Elizabeth Everts
(802) 592-3088
elizeverts@yahoo.com).

» **Lunenburg, on the town
common on Route 2**
Wednesdays 2 pm to 6 pm
Lance Roberts
(802) 892-1262

» **Craftsbury, on the common**
Saturdays 10 am to 1 pm
Tule Fogg
(802) 586-2571

» **Derby, on Route 5
next to the Elks Lodge**
Saturdays and Tuesdays 9:30
am to 2:30 pm
Jack Stouffer
(802) 334-2580
gardenymom@hotmail.com

» **Greensboro Town Hall,
on the green**
Thursdays 3 to 6 pm
Brian Titus
(802) 533-7455
info@woodsedgefarm.org
www.greensborofarmersmar-
ket.com

» **Newport, on the Causeway**
Wednesdays and Saturdays 9
am to 2 pm
Judy Szych
(802) 334-6858
sunny_in_vermont@yahoo.
com

» **Westmore, by the
Community Church**
Monday 1 pm to 6 pm
Sharon Strange
(802) 467-8531
wcrehome@wildblue.net

» **Willoughby Lake Farmers'
and Artisans' Market, on
Route 5A**
Thursdays 3 pm to 7 pm
Michelle Wildflower
(802) 525-8842
naturesmysteriesinfo@
yahoo.com

» **North Troy, at the Tranquil
Gardens Center**
Sundays 10 am to 2 pm
Jo Daggat
tjkat@myfairpoint.net

Things change in the world of farmers' markets. It's a good idea to check for updated details with the people who run the market. There are three websites that maintain up-to-date information on farmers' markets:

» Northeast Kingdom
Locavores
www.neklocalvores.word-
press.com

» The Northeast Organic
Farming Association
of Vermont
www.nofavt.org

» Vermont Agency
of Agriculture
www.vermontagriculture.com

farm and forest

Venison, wild leek soup, perch from a hole drilled in the ice of Parker Pond, fiddleheads in the spring—these wild foods seem to have more intense flavor than those that people create from domesticated products. The wildness itself has a flavor.

If you have ever picked wild blueberries you might know what I'm getting at by describing the "wild" flavor. Huge domestic blueberries are juicy and delicious, but wild blueberries are tiny yet somehow more extreme; for this reason they have their own appeal. Maybe it's simply because they aren't as easy to come by, and therefore we appreciate them a little more.

I do appreciate venison when I can get it from my son or another family member. I'm

not a hunter so I have to rely on others who might have a little extra to share.

Wild meat that hasn't been cared for well or that comes from an old or tough animal can be "gamey"—dank, pungent, and raunchy. Wild meat that is taken care of and cooked properly is tender and savory—delicious!

The next best thing to wild meat from the woods near my house is beefalo, a mix of domestic beef and buffalo. It has that hint of wild flavor.

It's important to cook beefalo slowly because there is very little fat. The burgers barely shrink while cooking.

When I mention how much I enjoy beefalo meat, people ask me how the two animal meats are mixed together. That's not what happens. A beefalo *is* an animal, part bison and part domestic beef cow. In order to be registered as a beefalo, it has to have three-eighths bison blood. Hair samples are sent out for DNA testing to determine the case for individual animals.

Dan Maclure of Farm and Forest Ranch in Orleans started raising beefalo in 2004. Mr. Maclure is in the real estate business, but grew up on a farm and ran his own dairy farm in Irasburg, which he sold in 1984.

He was glad for the opportunity to get back into farming because he likes working with animals. He's also glad to be able to keep one area farm from being divided and developed in small pieces.

Mr. Maclure found out about beefalo from a real estate client, Ed York, who bought Garvin Hill Farms in Greensboro. "He was the one that hooked me," Mr. Maclure says.

Beefalo are hardy and healthy, give birth to calves with little need for help, and do well on all sorts of feeds and pastures and in all kinds of conditions. The meat is lower in cholesterol than chicken, with about the same amount of calories and fat as chicken—considerably less than regular beef, so healthier for you.

The animals look much like other beef cattle. The most noticeable differences include hair that is curly and longer than regular cattle, and front shoulders that are wider and heavier—sometimes with a bit of a hump. Mr. Maclure's bull, Grey Ghost, is quite large and his hump pronounced. Colors vary. Some animals are almost pure white, others tan, red, brown, black, or some happy combination thereof.

Mr. Maclure's farm manager, Bob Butterfield, owns a few black Angus beef animals on the farm as well. He's had great success in showing cattle and did well again in Fryeburg, Maine, in the fall of 2010. The Fryeburg Fair is two weeks long, a showcase for the top farm animals from all over New England. One of the Farm and Forest beefalo bulls got Reserve Grand Champion. Animals from this farm have been sold to farms in Pennsylvania, Maine, and Canada.

Farm and Forest Ranch beefalo is available at restaurants at Jay Peak, Burke Mountain (where beefalo stew meat is made into chili), Montgomery's Café in Newport, The Buzz in Bradford, the Parson's Corner in Barton, and Highland Lodge in Greensboro. In the summer, the Orleans Country Club offers a

above: Farm and Forest Ranch is a converted dairy farm with a gorgeous view.

previous page: Dan Maclure with some of his cattle.

at a GLANCE

Farm and Forest Ranch

Dan Maclure
2867 Maple Hill Road
Barton, VT 05822
(802) 754-2263
dan@farmandforest.com

delicious beefalo burger called the Big MAClure.

Individual packages of beefalo meat can be bought at Newport Natural Foods, Natural Provisions in St. Johnsbury, the Evansville Trading Post, the Barton Village Corner Store, and from the farm by appointment.

four winds farm

I wrote the story of our own dairy farm auction, held April 29, 1991, twenty years ago. Since then my kids have grown up, I've been through a divorce, my ex-husband has remarried, and I have a new sweetheart.

Some things have changed, but farmers have not. They still work extremely hard for very little income. They care about the food they produce, about their families, about their communities, and about the land.

I remember the day of our auction as if it were yesterday. At one point, just as things were getting started, I went down to the house to have one last glass of our own milk.

Jersey milk is extra rich in butterfat and protein, an important quality for making cheese. Raw Jersey milk takes some getting used to—it's almost

as thick, creamy, and rich as a milkshake, but not sweet. Once you develop a taste, however, the store-bought stuff is like eating canned tuna when you're used to lobster.

I remembered a dream I'd had the night before. I dreamed that along with the cows, my five-year-old son's cross-stitch sewing kit that his grandmother gave him was up on the block. Tristan considered a couple of those cows his, and he didn't think we should be selling something that belonged to him. His first sentence was, "Help Daddy milk cows."

When farming gets in your blood, there's not much you can do to shake it. But it's a difficult lifestyle. One reason so many farmers don't make much money is that they're willing to work eighteen-hour days, seven days a week, with very rare vacations, only to break even. Corporate America takes advantage of that.

Every time I drive by a dairy farm, I feel grateful that the farmer is still in business. I wonder if he is making ends meet, and if he is discouraged.

"The National Suicide Prevention Hotline is available

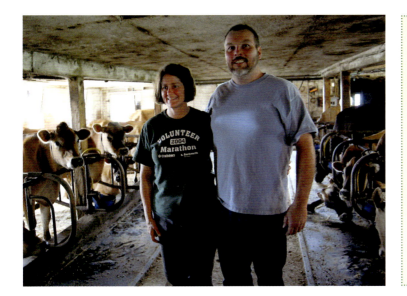

at a GLANCE

Mark Dunbar and Tule Fogg run this sixth-generation dairy farm and sell hand-painted T-shirts at the Crafts-bury Farmers' Market. The milk goes to St. Albans Cooperative Creamery. The dairy farm is not usually open to the public, but people can stop by and see the view with a call ahead.

Ketchum Hill Road Craftsbury, VT 05826 (802) 586-2571

to help," says a newsletter from the United States Department of Agriculture. "If you know a farmer or a rancher who is under stress and is reluctant to ask for help, or if you just need to talk to someone, call (800) 273-TALK (8255)."

How many other industries need a suicide hotline?

I'm extremely happy to say that the original Dunbar dairy farm in East Craftsbury is still thriving. My ex-husband Harvey's cousin, Mark, and his wife, Tule Fogg, are still milking a herd of those beautiful brown and black, doe-eyed Jersey cows.

Mark Dunbar is philosophical. He says if it comes right down to it, his priority will be saving the farm before he saves the cows. This farm has seen six generations of his family working the land. He certainly doesn't want to be the guy who loses it all.

Farmers' milk checks are up slightly, but the average cost of making milk in Vermont is still about $2 more for every hundred pounds than that check covers.

Mark and Tule have done a

lot to bring down expenses and draw in a bit of extra income here and there just to make ends meet.

On the farm, Mark teaches a basic tractor class to Sterling College students. Tule teaches art part-time and rides the school bus to work to save on gasoline. She makes and sells T-shirts and has started working as a caterer.

Their daughter Lily is in eighth grade. The couple's son John was valedictorian of his class at Craftsbury Academy and won a full scholarship to the University of Vermont, where he studies Russian.

Mark and Tule sell cull dairy cows as beef, but cull cows don't bring in much money these days. Recently, Mark sold an entire cow for only $59. He notes the price of burgers and hot dogs in the supermarket don't reflect the price paid to farmers any more than the price of milk does. "I refuse to pay money for a hot dog now," he says. In an effort to save money, he has switched to milking on a seasonal basis, taking two months off in the winter.

left: Mark Dunbar and Tule Fogg are the sixth generation on the Dunbar farm in East Craftsbury.

previous page: Tule Fogg sells her hand painted T-shirts at the Craftsbury Farmers Market.

"There're two months where I don't incur any expenses," he says. He doesn't feed much grain. "I quit growing corn," he says. That saves on equipment and fuel. "We need to think outside the box."

Tule Fogg sells her T-shirts at the Craftsbury Farmers' Market in the summer. Their farm's milk goes to the St. Albans Cooperative Creamery. The farm is not generally open to the public, but Mark might be free to show it to visitors if they call ahead. Sometimes, drivers stop to take photos of his land. It's a beautiful hill farm with a spectacular view.

The trouble is, it's hard to milk that view and make cash from it.

good life

How do we get children to eat better food? Let them grow it. First Lady Michelle Obama is setting a great example with her White House garden, grown from seeds from High Mowing Farm in Wolcott, Vermont.

Based in this corner of the state, the Green Mountain Farm-to-School program is spreading rapidly, with twenty area schools growing their own food in school gardens. It's getting children involved, and guess what? They love their vegetables when they grow them themselves! Schoolchildren in the Northeast Kingdom actually clamor for more rutabagas!

Katherine Sims, executive director of the program, collects comments from children, hot lunch cooks, teachers, parents, and others involved in farm-to-school programs. One of her favorite voices is that of Becky Koennicke, food service director at Glover's school, who says, "Can you grow me more rutabaga? The rutabaga we had last year was really well received."

It's no wonder a program like Green Mountain Farm-to-School would get its start in Westfield, home of some of the state's icons of agriculture and local food.

Natalie Gaines, originally from Syracuse, New York, first came to the area as a snowboard instructor at Jay Peak. "The opportunity will never be handed to you here. But there's so much you can make of it," Ms. Gaines says.

She had essentially no experience with agriculture or working on a farm when she first moved to Vermont. Since then she has jumped right in with

both barn boots. For example, she's started a community supported agriculture (CSA) group called Good Life Valley Farm.

She also milks cows for Lyle and Kitty Edwards on their organic farm in Westfield, where the CSA is based. "I want to start a herd. I want to farm someday," she says.

The Edwards have given her a head start with a heifer calf. Ms. Gaines named her Bella, after the heroine of Stephenie Meyers' *Twilight* novels.

She and her partner, Corey Guillette, are building up their herd. At this point, they milk seven cows. Mr. Guillette inherited an eight-gallon butter churn, which the two are considering putting to use.

Ms. Gaines teaches art and has taught special education, as well. She's seen firsthand how well students respond to fresh garden foods they help grow.

At first, kale salad is pretty weird to most kids. However, when they actually try it—and like it—the next thing you know they are raving to their parents about it. "The kids bring that knowledge home," says Ms. Gaines.

at a GLANCE

Natalie Gaines and Corey Guillette have a CSA and are building a dairy herd at Good Life Valley Farm.

3206 East Hill Road North Troy, VT 05859 (802) 673-5937 natalie@goodlifevalleyfarm.com natsgardens@gmail.com www.goodlifevalleyfarm.com

above: Left to right are Kris Sulzman, Natalie Gaines, and Kitty Edwards. The three women enjoy a tea break while working on Ms. Gaines' CSA at the Edwards' dairy farm in Westfield.

left: Fiona and Ruby observe Ms. Sulzman weeding.

previous page: Ms. Gaines with her heifer calf, Bella.

BARNS

The Kingdom's many dairy barns are the architectural vestiges of Vermont's dairy industry's heyday. In 1930s Kingdom, cows easily outnumbered people. At that time, sixty-five percent of the total farm income was derived from dairy product sales. Today, however, it can be difficult to find a working dairy farm. Keep an eye out for a barn's attached milk house—a small structure added to a barn's side—that will indicate whether the farm still produces dairy. Since the onset of machine-milking in the 1950s, when many struggling farmers gave up their pails and sold their herds, most farmers have converted their barns to other uses. Here's a list to help you distinguish one barn from another:

» English Barns (1770s to 1900s): Usually measuring thirty to forty feet, these barns were built by early colonial farmers. Look for a pair of large, hinged wagon doors on the lateral side and unpainted vertical boards covering the walls. These barns typically lack basements and are built on level ground.

» Yankee Barns (1820s to 1900s): These barns are typically built into a hillside with animals housed at ground level. Manure is easily pushed into a basement below. Yankee barns often feature a steep roof, horizontal siding (to prevent draft), rooftop ventilators (for fresh air), windows, and an entrance on the small end.

» Late Bank Barns (1870s to 1900s): Bank barns are noted for their accessibility to two separate levels from one ground level. Like Yankee Barns, Late Bank Barns were usually built into a hill. The uphill end allowed wagons access to an upper hayloft, while animals were housed below. Keep an eye out for graceful gabled roofs and a decorative copula, which provide ventilation.

» Round Barns (1899 to 1920): Round barns are notable for their distinctive shapes, either octagonal, polygonal, or circular. These shapes were meant to promote efficiency, offering a greater volume-to-surface ratio and cheaper construction than square or rectangular barns. With the proliferation of machinery, however, the efficiency of these barns became insignificant and their popularity waned.

Craftsbury Outdoor Center
(continued from page 43)

535 Lost Nation Road
Craftsbury Common, VT 05827
(802) 586-7767
stay@craftsbury.com
www.craftsbury.com

Sterling College Farm and Gardens

At this small liberal arts college, students study sustainable agriculture, conservation ecology, and natural history. Classroom discussion is supplemented with hands-on learning and frequent field trips. Guests are welcome to visit Sterling's Brown Library and take a guided campus tour.

Tim Patterson
16 Sterling Drive
Craftsury Common, VT 05827
(802) 586-7711
tpatterson@sterlingcollege.edu
www.sterlingcollege.edu

DANVILLE

American Society of Dowsers

Learn about the practice of dowsing and its applications to the resolution of para-psychological phenomena. Books and tools can be found at the ASD bookstore, and the annual convention is in June at Lyndon State College.

184 Brainerd Street
Danville, VT 05828
(802) 684-3417
asd@dowsers.org
www.dowsers.org

Diamond Hill Store

The shop purveys Vermont-produced cheeses and wines, as well as other specialty goods, both local and imported. Look for the display of fourteen international flags on Route 2.

Open Mondays through Saturday 10 am to 6 pm, and Sundays 12 noon to 4 pm.

Tom Beattie and John Dauteuil
P.O. Box 23
Route 2-11 East
Danville, VT 05828
info@diamondhillstore.com
www.diamondhillstore.com
(802) 684-9797

Emergo Farms

(see page 40)

261 Webster Hill
Danville, VT 05828
(802) 684-2215

Great Vermont Corn Maze

Voted the second-best corn maze in America (number one is in Dixon, California), this ten-acre tract of land boasts two miles of labyrinthine trails. The site hosts laser tag games, a haunted-maze event for Halloween, and child-

Patrons outside of Stardust Books (Photo courtesy of Stardust Books and Café)

friendly attractions including a petting zoo.

Open August through October.

1404 Wheelock Road
Danville, VT 05828
(802) 748-1399
info@vermontcornmaze.com
www.vermontcornmaze.com

Hollow Wood Farm

Sells vegetables at farmers' markets only.

31 Chet Willey Road
Danville, VT 05828
(802) 684-9706
info@snugvalleyfarm.com
hollowwood@kingcon.net

Lewis Creek Jersey/ Badger Brook Meats

Sells organic, grass-fed Angus beef and lamb. Some products are only available seasonally.

Vince Foy and Deb Yonker
565 McDowell Road
Danville, VT 05828
(802) 748-8461
debvince@danvillevt.net
debvince@danille.net

New England Tree Climbing and Twin Pines Recreational Tree Climbing LLC

An amazing experience that offers two levels of tree-climbing classes for ages six to eighty-five. Whether you choose the introductory "adventure climb" or the more intensive "basic climb," all equipment is supplied, and safety is of the utmost importance.

Al and Brenda
299 Maple Lane
Danville VT 05828
(802) 684-9795
(802) 684-2164
al@newenglandtreeclimbing.com
albrenda1@myfairpoint.net
www.newenglandtreeclimbing.com

Second Chance Farm

Offers pasture-raised, certified-organic Angus beef, freedom ranger chickens, red bourbon turkey, Tamworth breed pork, one hundred percent natural lamb, and eggs.

Open Monday 9 am to 6 pm.

Penelope Lowe
842 Fellows Road
Danville, VT 05828
(802) 748-8461
penelope@wildblue.net

Red Sky Trading (Photo courtesy of Red Sky Trading)

Tannery Farm Cashmeres

Owners Shirley Richardson and Mike Smith provide a bevy of goat-derived products such as cashmere breeding stock, hides, and raw cashmere fleece. A special type of goat meat called Chevron, which is low in fat and high in protein, is for sale at the farm's market.

173 Crystal Avenue
Danville, VT 05828
(802) 684-0174
tanneryfarm@gmail.com
www.tfcashmeres.com

DERBY

Cinta's Bake Shop

Taste the baked creations of Cinta Ahrens, who puts her thirty-five years of experience to tasty use at her eponymous shop. Pick up fresh bagels, doughnuts, pies, breads, and other goodies.

Open Monday through Friday 7 am to 4:30 pm, and Saturday 8 am to 2 pm. Closed Sunday.

3197 U.S. Route 5
Derby, VT 05829
(802) 766-5080

The Derby Cow Palace Restaurant

A unique dining experience in the heart of the Northeast Kingdom. This place is famous for its elk venison meat and is open for lunch and dinner. A herd of elk roams in the pasture alongside.

Open for lunch Tuesday through Sunday 11 am to 4 pm, and for dinner Monday through Sunday 4 pm to closing.

Missy Nelson
U.S. Route 5, Main Street
Derby, VT 05829
(802) 766-4724
missyatcp@yahoo.com

Hollandeer Farm

Husband and wife team Harold and Diane Rowlee raise red deer at the farm and offer a variety of venison cuts and flavors for sale. Their herd has been part of the CWD Monitoring Program for over eight years.

58 Stage Coach Lane
Derby, VT 05829
rowlee@hollandeerfarm.com
www.hollandeerfarm.com

Vermont Heritage Spring Water

The company bottles and distributes natural spring water and other products from their Beebe source. They also offer Green Mountain Coffee delivery service to office and home accounts in the Northeast Kingdom.

3662 N. Derby Road
Derby, VT 05829
(802) 334-2528
vt.water@comcast.net

DERBY LINE

Border Farm Maples

The Davis Family's maple syrup won Best in Show of all producers at the Vermont Farm Show in 2011. The family has been mak-

Agape Hill Farm (Photo courtesy of Agape Hill Farm)

COW SPOTTING

To each his own . . . cow. Farmers tend to favor certain breeds of cows depending on what the ruminant has to offer: the sweetest milk, the most butterfat, even the most cordial personality. Here are the more popular breeds of cows that you might encounter in the Kingdom:

» **The Holstein:** For most people, this is the archetypal cow. Having originated in Europe, these cows were bred to make the best use of grass and wound up the most popular dairy producer. Ben and Jerry's features the distinctly-marked black and white Holsteins on their ice cream containers.

» **The Jersey:** If you've ever eaten Borden cheese or milk, you've probably seen Elsie the Cow, their famous Jersey mascot. Jerseys are known for their docile dispositions and the rich, high butterfat content of their milk. Typically brown, but sometimes black, these small and genial cows give the largest ratio of pounds of milk to pounds of cow than any other breed.

» **Guernsey:** Bigger than Jerseys but smaller than Holsteins, Guernsey cows are known for their milk's rich flavor and high beta-carotene content. They are orange-red in color, often with white legs and body markings.

» **Scottish Highland:** These cute cattle are a dual–breed, used both for milking and for beef. They are distinguished by their long, wavy coats (typically black, brindle, red, yellow, or dun in color) and their upturned horns.

» **Beef cows:** Grown for meat, there are many breeds of beef cow. These chubby cattle include the Hereford (black or brown with white faces), the Dutch Belted (the "Oreo Cookie Cow"), and the Black Angus.

ing maple syrup on a spectacular farm just south of the Canadian border for fifty-two years. The extended Davis Family milks 100 cows and gets some of the farm's electricity from wind power.

Roy and Shirley Davis
160 Holland Road
Derby Line, VT 05830
(802) 873-3240
bryan@bordermaplesyrup.com
bordermaplesyrup.com

Haskell Free Library & Opera House

Stand with a foot in two countries at this century-old landmark straddling the U.S. and Canada border. Visit the ground floor library and the second floor Opera House, which now serves as a stage for performers and public speakers.

93 Caswell Avenue
Derby Line, VT 05829
(802) 873-3022
haskelllibrary@haskellopera.org
www.haskellopera.org

Northeast Maple Products

Boils and sells several kinds of maple syrup including grade B, grade A fancy, and A amber. They also sell jelly, dressing, and butter made from their syrup, all of which you can purchase on their website.

608 Elm Street
Derby Line, VT 05830
(802) 873-9132
(802) 673-6093
danny@northeastmaple.com
www.northeastmaple.com

continued on page 70

highland cattle

Melanie and Fran Azur of Newport Center and Pennsylvania are the owners of the Vermont Highland Cattle Company, based in Orleans. They also own a stable of Standardbred racehorses, a boon for all of us who enjoy the sport of harness racing.

For the past two years the Azurs have helped "beef" up the races at the annual August Orleans County Fair.

In 2009, they brought two of their top racehorses for a demonstration race. Noble Falcon broke the record for the state of Vermont that day. They also put $16,000 into the purse for race winners, which brought more racers to the fairgrounds.

The Standardbred breed is not as famous as the familiar Thoroughbreds in the Kentucky Derby, but is less high strung and delicate—more versatile and suitable to retrain as a trail horse. I owned a retired Standardbred for twelve years named Music. She was sweet-natured and reliable, and I often put little children on her for rides through the country.

The Azurs have bought the former Ethan Allen furniture factory in Island Pond with an eye to converting it to a wood pellet plant; the plant has been sitting empty for years.

Vermont Highland Cattle Company owns 577 cows, mostly Scottish Highlanders—shaggy-haired, hardy creatures with long horns—and they have started doing some crossbreeding with Angus. The Azurs own 2,300 acres that account for six farms in Newport Center, Troy, and Lowell. The beef is not completely organic but the animals are totally grass-fed.

The Azurs have bought a processing plant in Orleans. At Azur's Custom Meat Processing they make beef and beef jerky. They have a new smoker and hope to be processing ham and sausage by next year. They continue to make frequent donations of beef to local schools.

"Fran and I are pretty active in philanthropic ideas," says Ms. Azur. The two started the Bartko Foundation using Ms. Azur's maiden name, to help single minority women find education, transportation, and housing in Pittsburgh.

Mr. Azur has hunted all over the globe, including alligators in Louisiana and bears in Alaska. The Azur's house is decorated with some truly impressive trophies.

Josh Mason is the general manager of Vermont Highland Cattle Company, and Ray Edwards manages Azur's Custom Meat Processing.

"Everybody is more and more concerned with where the animals are grown and how they are treated," Mr. Edwards says. Animals at the Vermont Highland Cattle Company have a good life. Young animals are kept with their mothers for five or six months. "They learn how to graze and how to be a cow."

The Azurs are clearly quite proud of their cattle. Some of their bulls have won national championships. "They love to be brushed and spoiled," Ms. Azur says affectionately.

The Azurs also make maple syrup and have 6,000 taps.

at a GLANCE

Vermont Highland Cattle Company

326 Industrial Park Lane Orleans, VT 05860

By appointment, any of the farms, Vermont Highlands Maple Syrup, or Azur's Custom Meat Processing can be visited. Please call (888) 243-8218 or (802) 754-2300.

below: Left to right are Fran and Melanie Azur, Sheri and Kevin McDermott, and Noble Falcon. The Azurs own Noble Falcon, and Mr. McDermott is his trainer.

previous page: Steers at the Vermont Highland Cattle Company.

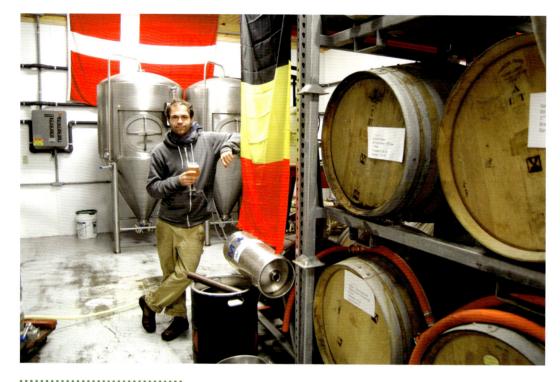

hill
farmstead

I am beginning to think of Shaun Hill as the Einstein, or perhaps the Beethoven, of beer. His hairstyle works either way. A philosophy major, Mr. Hill is driven to create beers beyond the basic melodies or scientific equations that produce merely "acceptable" results.

It's fun to see someone's face light up the first time they try Hill Farmstead beer. Even those without a general affinity for the libation tend to enjoy these varieties, some of which are aged in classic bourbon and wine casks.

The Hill Farmstead varieties I have tried are rich, refreshing, and crisp. Some are hoppy, some are made in the "Belgian style," some have hints of fruit flavors, and none are overly sweet. Some have more alcohol than the average beer. And their dark beers aren't tainted with the bitterness or thick molasses flavor I associate with dark beers I've tried in the past.

Hill Farmstead can be more expensive than your average beer, though not prohibitively so. For $15 you can fill a two-liter growler with an India Pale Ale you won't soon forget. (The growler itself costs $10 bucks, but just think of all those cans and bottles you don't have to bother returning!)

The brewery opened in 2010, and my sweetheart Jim Bowes and I went over to Greensboro on Memorial Day weekend that year to celebrate. We tried the Edward and Abner varieties and got T-shirts, glasses with the farm logo, and a growler for later.

The live jazz music was great, and the trout cakes made by Laura Thompson of Parker Pie were a phenomenon. It was a good time had by all who turned out to give the new brewery a try.

That day certainly felt like the start of something important. Waiting in line for a glass of beer reminded me of waiting in line in college—back at the University of Vermont in the late '70s—when a couple of guys were making ice cream. Those two guys were Ben and Jerry. The ice cream was worth the wait, and everyone knew it.

Shaun Hill grew up in the Greensboro farmhouse where he lives. He got his start

at making beer with a high school science project.

He went on to attend Haverford College in Pennsylvania and wrote his thesis on the role of the intellectual in education. After college he worked painting houses and traveled in the winters.

His travels took him to Denmark. There, he worked in a brewery where beer he created won two gold awards and a silver award at the World Beer Cup in Chicago.

"I am a discriminating human being who is opinionated," he says. "I'm going to continue to push the boundaries of what good can be."

He compares his desire to make exceptional beer to the way Bob Dylan made music in 1965. He was "channeling something profound," as Mr. Hill puts it. The fact that Mr. Hill was yet to be born in 1965, but still uses this example, gives credence to the concept that true quality is timeless, if hard to define.

"What is beauty?" Shaun Hill asks. "I don't know. Honestly." But people know it when they see it, and they definitely see it in his product.

Mr. Hill points out that the local food movement is not new in the Hardwick area, even though Hardwick has only recently become a poster town for it. For example, the Buffalo Mountain Co-op has been serving the public with local foods for thirty years.

Since 1780, Mr. Hill's ancestors have farmed the same land on which he makes beer. He names his beer varieties after them, in recognition of their efforts. "They struggled for 200 years as dairy farmers," he says. But the dairy farming tradition ended in the '70s. "My grandfather's barn burned down in 1978, and it wasn't rebuilt."

The Hill Farmstead logo is a design taken from a tavern sign found in Lewis Hill's home. The sign belonged to one of their common ancestors, Aaron Hill. "I think what Hill Farmstead has that is different," he says, "is a ridiculously long heritage."

Edward Hill was Shaun's grandfather; Ephraim was his great-grandfather. Edward's first cousin was Lewis Hill, who raised and sold fruit trees and perennial flowers, in particular day lilies. He also wrote books about gardening and perennial plants, as well as a book about his own youth called *Fetched Up Yankee.*

Some of the fruit trees that this farmer-cum-author planted produce fruit that might wind up in Hill Farmstead beer. "We're going to start doing some stuff with local berry and fruit producers," he says.

Although Mr. Hill's ambitions are nothing less than to achieve greatness through his beer, he wants to keep Hill Farmstead intimate. The farm's capacity is about four times the amount of beer currently produced, a limit that he does not plan to increase.

at a GLANCE

Hill Farmstead beers can often be found on tap at Parker Pie in West Glover, Claire's Restaurant and Bar in Hardwick, the Three Penny Taproom in Montpelier, or at the farmstead in Greensboro, which is open Wednesdays through Saturdays, 12 noon to 5 pm.

*403 Hill Road
Greensboro Bend, VT 05842
(802) 533-7450
www.hillfarmstead.com*

left: The Hill Farmstead growlers are reusable and cost $10. The logo is based on a tavern sign of one of Shaun Hill's ancestors.

previous page: Shaun Hill ages some of his beer varieties in oak casks for three months. He plans to age some for two years for special releases. The flags are from Denmark and Belgium.

jasper hill

"If we want things to remain the same, then something's going to have to change," says Mateo Kehler at Jasper Hill in Greensboro.

Mr. Kehler is talking about the dairy industry in Vermont. "When you see a farm that is vibrant and productive, and people are able to make a living, that's about as good as it gets," he says.

Mr. Kehler would like to see more farms in Vermont thrive. He uses France as an example to follow. There, they have a system of classification, where farmers in one region—take Comté—all produce the same type of cheese, which is then named after that region.

Three thousand dairy farms in a region the size of the Kingdom make Comté cheese, the price of which is based on qual-

ity as determined by a team of taste-testers. A breed of cattle called Montbeliarde, similar to the Ayrshires at Jasper Hill, is used to make the cheese.

The Cellars at Jasper Hill thrives. Its main goal is to work with area farmers to keep the landscape producing. Brothers Mateo and Andy Kehler, along with their families, bought the Jasper Hill farm in 1998. They started making cheese in 2003 and decided to build a system of cheese caves—cellars—to age their own cheese, and work with other area farmers and cheesemakers. The cellars were built in 2008, and they are forty percent full.

"We could fill our cellars right now," says Mr. Kehler, "with cheeses from all over the United States and Europe." But his hope is to fill them with local cheeses. Jasper Hill works with Cabot Creamery to age an old-fashioned clothbound cheddar, as well as with smaller cheesemakers including Ploughgate Cheese of Albany.

"The Food Venture Center is really exciting for us," Mr. Kehler says. "We just hired five people in preparation for that."

Under construction in Hardwick, the Venture Center will include a cheese production section that Jasper Hill has agreed to lease for five years.

The farm makes 80,000 pounds of cheese a year, and business has grown quickly. By 2010 it had grown fifty percent from the previous year, and 2011 is looking strong.

As for workers, Jasper Hill will employ twenty-nine people by the end of the first quarter. Four years earlier they had only four employees.

"The point of all this is to keep people on the land," Mr. Kehler says. "We've got to look back at what our agricultural economy and our landscape looked like before World War II. St. Albans was the butter capital of the world. I think that we have the potential to get back there."

While things are going well, Kehler doesn't expect to make huge changes overnight. "We always figured this was a generational project. We've bitten off a life's work," he says, adding, "To some degree we're making it up as we go along!"

at a GLANCE

The Cellars at Jasper Hill and Jasper Hill Farm

Jasper Hill cheeses are available at Willey's General Store in Greensboro, Buffalo Mountain Co-op in Hardwick, the St. Johnsbury Food Co-op, Red Sky Trading Company in Glover, Pete's Greens in Craftsbury, Hazendale Farm in Greensboro, Diamond Hill in Danville, and at the farmers' markets in St. Johnsbury, Danville, and Hardwick. Not open to the public except for special events.

884 Garvin Hill Road Greensboro, VT (802) 533-2566 info@jasperhillfarm.com

above: The facade of The Cellars at Jasper Hill has a futuristic look. Visitors had a chance to tour the during Sterling College's Rural Heritage Institute, but conditions must be strictly protected inside.

left: Brothers Andy (left) and Mateo Kehler stand with some of their Ayrshire dairy cows.

previous page: Rows of cheeses aging in one of the seven sections in the Cellars at Jasper Hill.

jay peck

"There's a real appreciation for what the Vermont brand represents," says Bill Stenger, president of Jay Peak Resort.

On the day of the opening of the Tram Haus hotel in 2009, Mr. Stenger was dubbed the "King of the Kingdom" by Chuck Ross, Vermont's current Secretary of Agriculture. Jay Peak has created hundreds of desperately needed jobs in the Northeast Kingdom, many of which were created through a program called EB-5, which offers green cards and a route to United States citizenship for foreign investors who put at least $500,000 into a development that will create at least ten permanent jobs in economically hard-hit areas of the country.

As someone who sells the Vermont brand every day, Mr. Stenger knows why people want the "Vermont" experience. They expect it to be clean, healthy, safe, and authentic. That extends to the local food movement: "It's an initiative that's gaining momentum," he says.

Menus at Alice's Table and the Tower Bar in the new hotel at Jay Peak reflect this trend. Both restaurants highlight Vermont apple cider, organic greens, Cabot cheddar, Vermont bacon, and beer made especially for Jay Peak by Long Trail called Jay Peak Tram Ale.

Mr. Stenger notes that the chefs started their own gardens at the resort in 2010 so they could step outside to pick fresh

at a GLANCE

Jay Peak Resort has a ski area,
ice arena, and golf course.
A water park is in the works.
Alice's Table restaurant and
the Tower Bar feature local
and Vermont ingredients.

4850 VT Route 242
Jay, VT 05859
(802) 988-2611
www.jaypeakresort.com

right: A snowy scene at Jay Peak Resort.

previous page: The Tram Haus hotel at Jay Peak was opened in 2009.

herbs and greens. "It went well, and we will expand what we do going forward."

Jay Peak has supported farmers through the Green Mountain Farm-to-School program. "That's been kind of enlightening," he says, referring to his new knowledge about local food options.

But support for local farmers is nothing new at Jay Peak. "We're physically on the line between Franklin and Orleans counties," Mr. Stenger says, "two of the biggest agricultural counties in Vermont. The relationship with the farm community is pretty indelible, and it goes deep."

An example of Jay Peak's dedication to the region's local producers is Farmer Day. Once a year, farmers get free lift tickets and special deals on rentals and lessons. "We almost always have 400 to 500 farmers participate," says Mr. Stenger. He added that many of them go out of their way to thank him, and he's happy to support the backbone of the community.

Going forward, Mr. Stenger plans to work with dairy farmer Doug Nelson of Derby to use a by-product from the farm as

an energy source for the water park he is building. "It's really a green technology to take manure, convert it to methane, further convert it to propane." Starr Transportation, owned by state Senator Bobby Starr of Troy, will truck the propane to the mountain.

"Anything I can do to support farmers, I'll do," Mr. Stenger says. "We need to be actively engaged in supporting farmers or we lose them. You can't leave it to somebody else."

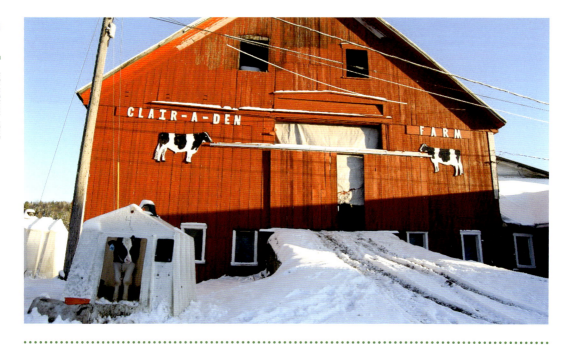

kingdom creamery

The Michaud family at Kingdom Creamery offers basic, simple ice cream in flavors that taste like home made.

The Michaud family in East Hardwick had been thinking about making value-added products for their dairy farms for quite some time before they decided to build a creamery. The extended family wanted to stay in farming and wanted a way to take some control of the price they are paid for their milk.

"We had discussed it as a family in 2006," said Jeremy Michaud in an interview at the family's farm.

The Michauds own two big dairy farms — about 600 milking cows in all plus 550 head of young stock.

"This is a long-term solution for our family."

The family members involved in the dairy farms in-clude Mr. Michaud's parents, Denis and Claire, his grandmother, Marie Paule, his two brothers, Travis and Daniel, and all three brothers' wives and children.

"We all grew up here," says Mr. Michaud. "The farm was started in the early '50s by my grandparents, who were Canadian immigrants."

His grandfather, Yvon, died about ten years ago.

"My father took over the farm right out of high school."

The Michauds have already had some success at side businesses while maintaining dairy farms all along. Denis Michaud started a septic business in 1980, and Claire Michaud had a hairdressing business. They also had businesses maple sugaring, selling Christmas wreaths, raising and selling Devon cattle, and making and selling compost.

"That came about by accident," says Jeremy Michaud. People heard they were making compost and just started showing up asking to buy some. So far they have only sold it in bulk, but they are thinking about bagging and selling smaller quantities.

So going into a new business wasn't a foreign idea for the Michauds.

"We've got our feet in a lot of different puddles."

Jeremy Michaud and his two brothers went to college and came home hoping to make a go of it farming. Jer-

left: A calf at the Michaud farm peeks out from its hutch. The farm's name, Clair-a-Den, comes from Claire and Denis Michaud's names.

previous page: The Kingdom Creamery has equipment for pasteurizing, mixing, and adding ingredients and for packaging ice cream, yogurt, and mixes, plus a walk-in freezer. Left to right are Lincoln, Morgan (holding Dawson in the stroller), and Gabriel Michaud.

emy went to Cornell and his brothers both went to SUNY in Morrisville, New York.

But federal milk prices were so bad in 2009 that they began to wonder if they could make it work.

"You end up fighting with each other over the stupidest things," Mr. Michaud says.

That year they decided, as a family, to seriously look into making a value-added product. They got a lot of help from the Farm Viability Enhancement Program and a business planner, Rosalie Wilson of Norwich.

The Vermont Agency of Agriculture was a great help. The Michauds got some grants to help make the project feasible.

Jeremy Michaud says they realized there are a number of people making artisan cheeses and they decided to do something different.

"We needed our own niche."

Once they had come up with the name Kingdom Creamery they started looking at some possible labels and logos. As it turned out, the youngest generation picked their favorite — a cow and a knight back to back with each other, along with some properly Medieval-looking text.

In addition, the youngest generation has been helpful in trying out ice cream recipes. At this point, the Michauds are making maple-flavored ice cream with their own maple syrup, along with maple sugar, chocolate, vanilla, coffee, and strawberry flavors.

"Our maple is probably the best," says Mr. Michaud. "I don't think it gets any more Vermont than that."

At this point, Mr. Michaud says the plant they've built can handle four to five million pounds annually, and the family's farms make fourteen million pounds.

Asked if the plant can handle all of it, or if they might buy milk from neighbors at some point, Mr. Michaud says, "We'll cross that bridge if we are ever fortunate enough to get there."

They are hoping to be able to sell 70,000 gallons of ice cream, 24,000 gallons of yogurt, and 12,000 to 15,000 pounds of ice cream mixes.

"We're out on a limb," Mr. Michaud says, but adds, "You look at the kids, and that's all the motivation I need to keep going. They're playing farm in the living room."

So far the Kingdom Creamery has hired a creative

at a GLANCE

The Michaud family in East Hardwick built a creamery to make the milk they produce on their family farms into ice cream and yogurt. The company is called Kingdom Creamery, and the products can be found at grocery stores around the Northeast Kingdom. The label design was chosen by the youngest generation of Michauds who liked the 'kingdom' theme and cartoon cow.

3617 Route 16
East Hardwick, VT 05836
(802) 472-6700
www.kingdomcreameryofver-mont.com

director, a sales and marketing person, and a plant manager. Jeremy Michaud is the general manager.

The rest of the employees are extended family: Jeremy, Leslie, and their four children, Lincoln, Gabriel, Morgan, and Dawson; Travis, Crystal and their three children, Hunter, Haley, and Hadley; and Daniel, Emily and their two children, Natalie and Talon.

lazy lady

The Lazy Lady is anything but. Laini Fondiller is one of the hardest working farmers I know, and that's saying something. She has been making goat cheese since 1987. One might say she's a pioneer of Vermont's artisan cheese movement.

Feisty and outspoken, Laini Fondiller has been an advocate for small farmers and cheesemakers from the beginning.

Her days are long, occupied with forty registered Alpine goats to tend and cheese to make and sell at markets. But she says the life suits her. She's the type who would have found more trouble than pleasure at a desk job.

Lazy Lady Farm is "off the grid," making its own electricity thanks to seventeen solar panels and a small wind generator. Ms. Fondiller uses whey from cheesemaking to feed pigs she raises for pork and bacon. She also raises grass-fed beef.

And then there's the cheese: her website lists twenty-one varieties; however, she doesn't make them all at once.

"I do have to change cheeses according to temperature," she says. The Lady in Blue, a blue cow's milk cheese that is aged sixty days, likes temperatures around forty to fifty-two degrees. Ms. Fondiller can make it September through May.

Summer is time for a different cheese. "The bloomy rinds like the humidity," she says, so she waits for warm weather to make them.

Some of the names of Ms. Fondiller's cheese varieties reflect her other passion—politics. There is a Barick Obama, described as "washed rind, aged four to six weeks, pasteurized, soft elastic body."

The Condisend is made from milk from both goats and cows. It comes in a small package with a bloomy rind, and is mellow, but not wimpy.

La Petite Tomme is a soft, creamy, almost liquid-centered Brie-type goat cheese, mild, smooth, and fantastic. I encourage even the staunchest opponents of goat's milk cheeses to try this one.

Ms. Fondiller got her start in France, where she spent two years working on goat farms and trying hundreds of varieties of cheese. She was inspired to try goat farming herself and began her business with one goat named Blooper. She never looked back.

In 1995 she and her partner Barry Shaw built their first licensed cheese plant—a ten-by-twelve-foot room—and made cheese in five-gallon batches. In 1996 she built her first cheese cave and recently added a second one. The temperature in these rooms is controlled only by the ground itself, which saves electricity but means the varieties must be timed according to the season.

Ms. Fondiller is pleased to see all the attention local food and cheeses are getting these days. "I appreciate it, that's for sure," she says.

above: These goats are registered Alpines.

left: The door of one of the Lazy Lady cheese caves.

previous page: Lazy Lady cheeses age in the cave.

the meyer family business: the best milk in the east

In 1978 Steve and Patty Meyer started dairying, shipping their milk to the Cabot Farmers Cooperative Creamery. They raised four sons, three who are still involved in agriculture locally.

Nick and Taylor Meyer milk cows at North Hardwick Dairy—the farm they went organic with in 2003—and now ship milk to Organic Valley.

The brothers put up a wind tower to help provide electricity to the farm and are growing sunflowers to provide biodiesel for the farm's energy needs, and to use as meal for grain.

In 2009, United States Senator Pat Leahy came to Hardwick to see the Meyers' sunflowers grow, and to award a federal grant for $13,000 to study the energy uses and general business potential of sunflowers.

"Thank you for what you're doing. You're preserving the Vermont that I grew up in and that our children should be able

to grow up in," Senator Leahy told the family.

At the beginning of 2011, Nick reported that sunflowers as a crop were working, especially in good growing seasons. If the farm can make food-grade sunflower oil, sell it to local restaurants, then pick up the used oil for free, it will make even more financial sense. The used oil is just as good for cooking as it is for making biodiesel to run all the farm's tractors. Plus, the high protein sunflower meal saves about $20 to $25 in grain costs per animal per year, says Meyer.

The farm's milk has won awards as the overall highest quality milk in the state of Vermont for five years in a row and

awards from Organic Valley for the highest quality milk in the Eastern United States.

Down the road a ways, Nick and Taylor's brother, Andrew, runs two agriculture-related businesses, Vermont Soy and Vermont Natural Coatings.

Andrew Meyer spent some time in Washington, D.C. working for United States Senator Jim Jeffords. He has thought a lot about how to keep Vermont's agricultural heritage alive.

He says the best policy for Vermont is to not wait for Congress to repair the antiquated federal milk price system for commercial dairy farms.

"Vermont is small beans compared to the rest of the country," Meyer says.

Speaking of beans, Mr. Meyer has been doing trials with High Mowing Seeds on nine varieties of soy beans in order to see which will grow best in Vermont. He mentions that Jack Lazor at Butterworks Farm in Westfield, along with three other farmers on the western side of the state, are growing soy beans for Vermont Soy. Vermont Soy itself is growing, one might say, like a weed.

"We're starting to introduce products with a longer shelf life," he says. The company grew fifty percent in 2010 and employs six people.

Vermont Natural Coatings, which makes paints out of whey, doubled its sales in 2010, even in a difficult economy. "Once they see it, we convert them," Andrew says about potential buyers for his paint.

Mr. Meyer says he believes that small businesses in Vermont can develop methods and infrastructure that will allow for success. It's already started to happen, but there is a lot more to be done.

Growing and selling locally is wonderful, but to maintain Vermont's farms, markets outside the state must be developed as well. Mr. Meyer would like to see some infrastructure for farmers who possess a surplus of goods to sell to markets beyond the local level. A distribution system could be established that would source the rest of their produce to a larger market, he suggests.

A central facility where soy beans and other Vermont-grown grains could be stored, milled, cleaned, and distributed would also help. That way, each farm would not have to buy the expensive equipment needed for those tasks.

Another way farmers can maintain their land is through conservation. Conservation easements take the development pressure off farmers, and in some cases help non-farmers get into the business by making the price of the land in keeping with what it can produce.

The 218-acre North Hardwick Dairy land has been conserved through the Vermont Land Trust, and two of the Meyers' neighbors have conserved their own land as well, some of which the Meyers lease.

Conservation can help, but it's not a cure-all. Land values have to do with a property's views and location, not soil type or other important factors for growing crops. A farmer still needs a financial incentive to keep farming. "Someone should be able to afford the land just by working the land," Meyer says.

He and a few other people started the Center for an Agricultural Economy to study these issues and create solutions. "It's time to engage but be patient at the same time." There's a lot going on right now, and people are excited about it. But developing new systems for the local agricultural economy won't happen overnight.

at a GLANCE

Vermont Soy and Vermont Natural Coatings are part of the Center for an Agricultural Economy's monthly tour. North Hardwick Dairy is sometimes part of the tour.

North Hardwick Dairy sells its milk to Organic Valley and a portion of its raw milk to neighbors.

Vermont Soy products are available in local food co-ops and independent stores throughout Vermont including Buffalo Mountain Co-op and the Grand Union in Hardwick. They are also distributed throughout New England, New York City, and to schools including the University of Vermont and Middlebury College.

Vermont Natural Coatings is available from over 200 dealers in thirty-six states. Locally, try Willey's General Store in Greensboro and Poulin Lumber in Derby and Hardwick.

*northhardwickdairyfarm.com
vermontsoy.com
vermontnaturalcoatings.com*

left: Taylor and Nick Meyer put up a 100-foot wind turbine that they got from Vermont Green Energy Systems.

previous page: The Meyer family and Senator Pat Leahy with sunflowers at the North Hardwick Dairy. Left to right are Steve, Nick, Ella, and Tom Meyer, Senator Leahy, and Taylor, Sophia, Kris, Sara, Andrew, and Ella Meyer.

A DAIRY OF DISTINCTION

You aren't the only one noting the beauty of Vermont's farms. Each May, the Northeast Dairy Farm Beautification Program awards farms in New York, Pennsylvania, and New Jersey with the title "Dairy of Distinction." You might have noticed the distinctive white, black, and red signs. Judges base their selection of these farms on tidiness; attractiveness of grounds, lanes, and fences; cleanliness of animals, barnyards, and feed areas; manure management; management facilities; and overall beauty. These are places not to be missed.

EAST BURKE

Burke Mountain Club & White School Museum Burke Historical Society

P.O. Box 309
East Burke, VT 05832
(802) 626-9823
www.vermonthistory.org

Burke Mountain Ski Resort

Family-friendly slopes for downhill skiing, snowboarding, and cross-country skiing; trails for biking, hiking, and challenging runs; a 2000-foot vertical drop.

The site functions as a training ground for Olympic athletes. Open winter for skiing, snowboarding, and snow sports. Open summer for mountain biking.

223 Sherburne Lodge
East Burke, VT 05832
Toll-free: (888) BURKEVT
(802) 626-7300
info@skiburke.com
www.skiburke.com

D-N-D Stables

Small and intimate, the stables offer guided trail rides for all ages, and horse rides in the ring for younger or less experienced riders. Call for reservations.

Debby
1952 VT Route 114
East Burke, VT 05832
(802) 626-8237
dndstables1952@aol.com
www.horserentals.com/dnd-stables.html

East Burke Sports Shop

In East Burke Village just steps away from the Kingdom Trails, this shop offers a wide variety of sporting equipment and garb for the avid cyclist, skier, and outdoor enthusiast. They also house a full-service repair shop.

Open Monday through Saturday 8:30 am to 5:30 pm, and Sunday 10 am to 5 pm.

Route 114
East Burke, VT 05832
(802) 626-3215
www.eastburkesports.com

Inn at Mountain View Farm

A romantic country inn located on a 440-acre farm surrounded by the Kingdom Trails, which provide miles of hiking, biking, and cross-country ski and snow-shoe trails. Alpine skiing and snowboarding are readily accessible at nearby Burke Mountain Ski Resort.

Darling Hill Road
East Burke, VT 05832
(802) 626-9924
innmtnview@kingcon.com
www.innmtnview.com

Kingdom Trail Association

A multiple-use trail system voted Best Trail Network in North America by *Bike Magazine*, and Best of New England by *Boston Magazine Travel & Life*. A wild, pastoral setting for mountain biking, hiking, trail running, Nordic skiing, and snowshoeing.

P.O. Box 204
East Burke, VT 05832
April through November:
(802) 626-0737
December though March:
(802) 626-5863
(802) 535-5662
info@kingdomtrails.org

Mayflower Herb Farm and Sisters Herbals

A small-acre herb farm that focuses on organic growing and sustainably wildcrafting herbs. Owner Alyssa Doolitle produces many products from her plants, such as teas, salves, sitz baths, and tincture blends designed specifically for women and growing families. They are available for sale at Lyndonville Winter Market. Pick your own calendula and chamomile daily.

229 Gator Alley
East Burke, VT 05871
(802) 473-4009

Northeast Kingdom Online Country Store

Featuring wares from over fifty Northeast Kingdom artisans. Items for sale include maple syrup, specialty food products, wreaths, jewelry, books, and other handcrafted offerings.

466 Route 11
P.O. Box 212
East Burke, VT 05832
(802) 626-8511
www.travelthekingdom.com/country.store.php

Northeast Kingdom Travel & Tourism Association

The portal to help you plan your Northeast Kingdom vacation. They provide guides, travel tools, getaway packages, and useful information about the NEK and its possibilities.

P.O. Box 212
East Burke, VT 05832
(802) 626-8511
info@travelthekingdom.com
www.travelthekingdom.com

Vermont Youth Garden Project

The Vermont Youth Garden Project is teaching elementary and high school students about growing their own food, selling it, and making regular contributions to three area food shelves. People can get these vegetables and herbs through a community supported agriculture membership or at the group's farm stand in East Burke, staffed by students each Saturday through the growing season. Food is grown at the Inn at Mountain View, the Simpson farm, and the Mayflower Herb Farm.

PO Box 272
East Burke, VT 05832
(802) 626-5364
(802) 553-1070
Alyssa.vygp@gmail.com
vtyouthgarden@gmail.com
www.VermontYouthGardenProject.org

Village Inn of East Burke

A delightful bed and breakfast in the heart of East Burke that boasts a cozy living room with an open fire, an outdoor jacuzzi, and a guest kitchen.

Route 114
East Burke, VT 05832
(802) 626-3161
villginn@yahoo.com
www.villageinnofeastburke.com

EAST CHARLESTON

NorthWoods Stewardship Center

A nonprofit organization that provides high-quality scientific and educational conservation programs in northeast Vermont, including services in sustainble land management. Also offers outdoor recreation.

154 Leadership Drive
East Charleston, VT 05833
(802) 723-6551
info@northwoodscenter.org
www.northwoodscenter.org

EAST HARDWICK

Ben's Pumpkins

Snug Valley Farm is home to Ben's Pumpkins, which has over twenty years of experience growing pumpkins of all sizes for your autumnal needs.

824 Pumpkin Lane
East Hardwick , VT 05836
(802) 472-6185

Hazen Monument Farm

This two-generation organic dairy farm ships milk from eighty-two Holstein cows to Organic Valley and sells beef (in bulk), grass-fed meat, chickens, eggs, and pork. Farm tours are available for groups if people call ahead to make arrangements.

Roger and Patricia LeBlanc
1547 Hardwick Street
East Hardwick, VT 05836
(802) 472-5750
hazenfarm@vtlinknet

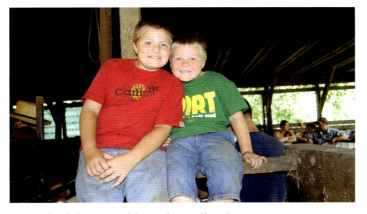

Bruce and Nicholas Stone each hope to buy a calf at a dairy auction.

continued on page 76

mountain foot

Curtis Sjolander's trout at Mountain Foot Farm in South Wheelock are not biting today. It's because there is a visitor.

The fish are used to having only one person in the barn. Ordinarily, they gobble up the pellets as fast Mr. Sjolander can throw them, but today the food floats on the surface, following the circular pattern of the water-flow in the big tanks.

I'm not exactly a great fisherman, but I have done enough to know that trout are wary. If they see a change in the shadows they won't bite. A fisherman must be quiet and clever to catch a brook trout for breakfast. In my experience, they hide under rocks.

The trout in these tanks are brown trout. "They're best from my point of view because they're hardier," says Mr. Sjolander. "There's lot of ways you can kill a fish by mistake."

For example, if the power goes off, no air flows into the water. "Within a half an hour they start getting stressed," he says. In case this does happen, he has a backup generator, but of course someone must be there to turn it on.

Mr. Sjolander's idea to raise trout started during a drought. Four years after he and his wife Joan built their house in 1984, things ran dry and he began looking for natural water sources. He found a beauty that flowed to the tune of thirty gallons per minute. "What do I do with that?" he wondered. Around the same time he saw

a television show called *Across the Fence* about raising trout. Eureka!

Mr. Sjolander learned many things about trout farming. Namely, that water temperature is critical to the trout's survival. So is their food, which is made out of protein and not grain. It's also important that they are not overcrowded.

All that is tricky enough before you start factoring in predators. At first, Mr. Sjolander raised his trout outside. Then his neighbors--the raccoons, skunks, otters, mergansers, and great blue herons—caught onto his scheme and cleaned him out of stock. To prevent this from happening again, he built a barn over the tanks. However, he quickly discovered that mink can climb through

fairly tiny holes. In 2010 he lost 2,100 trout to predators. (To give perspective, Mr. Sjolander raises between 3,000 and 4,000 trout a year.)

The fish reach full size, between eight to ten inches long, somewhere between two and three years old.

To raise extra capital, Mr. Sjolander works as a computer systems engineer three months during winters and does freelance software development. He also grows and sells vegetables, including wild colored potatoes and tomatoes.

He says he comes by his tendency to garden quite naturally. His mother always gardened and taught him how to grow. He was raised on an organic dairy farm, which today is run by his brother. "It was just expected. You always have big gardens," he says.

previous page: This potato is a Purple Peruvian. It's solid, keeps all winter, and is great for shish kebabs.

below: These young fish, or "fry," are about a half an inch long. Mr. Sjolander raises them from fertilized eggs he buys from the state of Vermont.

mountain view

In October, the Canada geese circle in loud, honking V-formation, getting ready to head south for the winter.

On one of these October days I noticed a swarm of gray and white phoebe birds flying around my house—swooping by the windows, perching on the walls, eating the sluggish cluster flies that take over the south side of the house on a warm afternoon—looking for a crack to invade.

At night I can sometimes hear the coyotes' wild calls sounding yi-yee-yee-whoo. Did they kill something? Are they celebrating? Perhaps they're just in a good mood.

Once, I caught sight of an owl in my car's headlights, teetering away into the darkness, swooping silently.

Vermont's state bird is the hermit thrush, a little brown, nondescript bird that is extremely difficult to spot but whose beautiful, haunting song echoes through the woods. The state animal is the Morgan horse, and I've got a fine specimen in my pasture. She is a show-off, graceful, strong, and fast—an extrovert.

The state car is a 1997 Subaru with 201,000 miles on it. I've got one of those in my driveway. In October, it's high time to get the metal-studded snow tires on.

During Vermont's glorious summers you can get local vegetables, jams, flowers, apples, and more at Mountain View Stand in Newport on any day of the week. This year, owner Barbara Judd of Morgan is leasing space for a winter farm stand for the first time.

She bought the Mountain View stand ten years ago, when she decided she wanted to work with local farmers. "Five years ago, I remember thinking, 'I am on the edge of something,'" Ms. Judd says.

Before buying the stand, Ms. Judd was a teacher for twenty-three years, so it comes naturally for her to explain the products to customers. "I can't just sell you something. I've got to tell you the story," she laughs.

She notes that local meats have grown in demand most recently. To accommodate her customers' wants, Mountain View started selling fish three years ago, and this year began to retail chicken and pork.

Mountain View has seventeen types of apples in various sizes, colors, textures, and flavors. One of them is called Blue Pearmain, a variety that Henry David Thoreau wrote about in his journal.

The stand sells lots of vegetables in addition to bread, pickles, jams, and sauces. The jam is created out of local berries and fruits, and carries the Mountain View label. The owner of another farm stand—on the western side of the state—has asked Ms. Judd about selling the jam herself.

"I'm going big. I'm in Franklin County!" Ms. Judd cheers with her arms in the air. "Smucker's, look out, here we come!"

above: Peppers (red, yellow, green, and orange) and squash create a rainbow of colors on the shelves.

below: Juicy ripe grapes are ready for eating plain or for making wine or jam.

previous page: At Mountain View Farm Stand in Newport you can find mums, pumpkins, tomatoes, and seventeen varieties of apples.

Kingdom Creamery

(see page 64)

3617 Route 16
East Hardwick, VT 05836
(802) 472-6682 (Denis and Claire
Michaud)
(802) 472-6261 (Jeremy Michaud)

Patchwork Farm and Bakery

Offers organic, artisan breads
baked in a wood-fired oven. Fresh
loaves are available at the Hard-
wick Farmers' Market as well as
local stores and co-ops, including
the Lake Parker Country Store
in West Glover and the Buffalo
Mountain Co-op in Hardwick.

Charlie Emers
182 Pumpkin Lane,
East Hardwick, VT 05836
(802) 472-3621
cemersleo@gmail.com

Riverside Farm

A luxurious private residence
that specializes in destination
Vermont weddings. They host el-
egant barn and outdoor ceremo-
nies and receptions, catered with
locally sourced ingredients.

117 Riverside Farm Lane
East Hardwick, VT 05836
(802) 472-6169
riversidefarmcsa@gmail.com

Snug Valley Farm

This family-run cattle farm
breeds all-natural grass-fed
Holsteins without the use of hor-
mones, stimulants, or additives.
In addition to beef, pumpkins,
pork, and firewood are for sale.
Visitors are encouraged to stroll
leisurely on the pastures.

824 Pumpkin Lane
East Hardwick, VT 05836
(802) 472-6185
info@snugvalleyfarm.com
www.snugvalleyfarm.com

Surfing Veggies

Named after Louis Pulver's love
of surfing, this farm has been
growing organic plant starts,
vegetables, and root crops for
cold storage since 1985. He and
Annie Gaillard sell their produce
and eggs at the Craftsbury and
Hardwick Farmers' Markets.

412 Richard Crossing
East Hardwick, VT 05836
(802) 533-7175
surfveg@vtlink.net

EAST RYEGATE

Red Gate Farm

Red Gate Farm sells hay from
165 acres, sixty-five of which are
certified organic. The farm sells
both square bales for horses and
round bales for cattle and sheep.

Walter and Karen Bragg
3294 Witherspoon Road
East Ryegate, VT 05042
(802) 584-3351

ELMORE

Elmore Roots

This certified organic nursery
has over thirty years of experi-
ence grafting and selling fruit
trees and shrubs. They offer
informative workshops about
growing as well as guides to the
wide variety of plants they sell.

Open spring, summer, and
fall (until October 31), Sunday
through Friday 9:30 am to 5 pm.

631 Symonds Mill Road
Elmore, VT 05680
(800) 42-PLANT
fruitpal@elmoreroots.com

GLOVER

Bread & Puppet
Theater, Museum & Press

The legendary political theater
company boasts one of the larg-
est collections of some of the
biggest puppets in the world.
They perform regularly in Glover
during summer months and
tour in Europe and the United
States the remainder of the year.
Sourdough rye bread and pun-

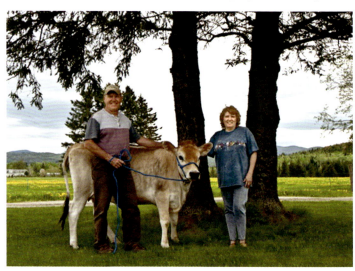

Baum Farm (Photo courtesy of Baum Farm)

gent aioli are served after every show by founders Peter and Elke Schumann and their puppeteers.

Open July through August, Fridays at 7:30 pm and Sundays (outdoors) at 2:20 pm.

753 Heights Road
Glover, VT 05839
(802) 525-3031
breadpup@together.net
www.breadandpuppet.org

Brown's Custom Meat Processing

Established in 1992, Brown's provides the community with a needed service in the butchering and packaging of beef, pork, lamb, and goat.

16 Larose Lane
Glover VT 05839
(802) 525-4044

Currier's Quality Market

Jim Currier and his family own and operate this general store that offers everything from rifles to snowshoes to homemade cookies. A veritable museum of taixdermied local wildlife, this market is a town meeting place. Try the dynamite breakfast at the scrumptious Wooden Spoon Deli, located conveniently within the store.

2984 Glover Street
Glover, VT 05839
(802) 525-8822
Deli: (802) 525-4464

Morningstar Meadows NOFA

This second generation farm is certified organic and grows and sells heirloom bean varietites. They also sell dry hay and straw, wheat and oat berries, and some vegetables. Belgian draft horses are raised and used for farming.

165 Dwinell Drive
Glover, VT 05839
(802) 525-4672

Powers Farm Stand

Located right off Shadow Lake Road, this family-run farm stand called Country Roads is open during summer months and sells delicious vegetables, pickles, jams, and pies. You can also take home elegant homemade quilts and pot holders.

Open May 15 through September 30, 9 am to 7 pm, seven days a week.

Gloria Powers
636 Hinman Road
Glover, VT 05839
(802) 525-9558

Red Sky Trading Company

Cheri and Doug Safford sell antiques and foodstuffs at this charming general store. Specials include homemade coconut macaroons, doughnuts, jams, local cheeses, goat milk soap, and eggs from their own free-range chickens.

Open daily May through October from 9 am to 7 pm.

Cheri and Doug Safford
2894 Glover Street
Glover, VT 05839
(802) 525-4736
info@redskytrading.com

Runaway Café

Serving breakfast and lunch prepared from locally-sourced, organic ingredients, this café also sells a wide variety of antiques and collectibles between 10 am and 5 pm at their Group Shop. Runaway is a member of The Vermont Fresh Network.

VERMONT CHEESE

Over the past decade, Vermont has forged ahead as the leader in the United States specialty cheese business. Whether it entails a gourmet offering served to judges as far away as Italy, or a silky-smooth blue ribbon Camembert sold to a local farmer, Vermont cheesemakers know their business. The Kingdom's local cheesemakers—Ploughgate, Jasper Hill, Lazy Lady, Bonnieview—all mostly use milk from their own cows, sheep, and goats and are quickly becoming renowned for the unique flavors of their cheeses. They mix old tradition with modern ideas to create some of the most delicious cheeses in the country!

Open Monday, Thursday, and Friday 6 am to 3 pm, and Saturday and Sunday 8 am to 3 pm.

316 Dry Pond Road
Glover, VT 05839
(802) 525-8891
runawaypond@gmail.com

continued on page 84

orleans and caledonia county fairs

August is fair time in the NEK. The Orleans County Fair is held at Roaring Brook Park in Barton, and the following week the Caledonia County Fair opens in Lyndonville. There are competitive shows for animals, vegetables, and quilts.

Picture this: Farmers on tractors pitted against each other to pull the most weight at one end of the fairgrounds, while horses pull huge blocks of granite in a similar effort on the other end. Other horses race around barrels in the gymkhana event, and around the newly finished racetrack pulling light carts at top speed; still more put up with costumes in parade classes.

The festivities at the county fair climax on Sunday with a demolition derby, where people smash into each other in old cars modified according to particular safety rules that include removing all glass and repositioning the gas tank to the back seat. I know this because my son first competed in the derby when he was seventeen years old. I sat in the stands, scared to death and proud as punch. He didn't win. But he didn't get hurt, either.

The food at the fair can be as scary as the derby or the rides that fling their riders up, down, and around, like the Zipper. I highly recommend not to

combine the two.

What we're talking about is fried dough topped with cinnamon and sugar, massive fried onions in batter and dipped in salad dressing, and fried sausages with fried peppers and onions.

After the kids have had their fill of naughty junk food, take them over to the maple

sugarhouse to get maple cotton candy. Granted, it's sugar, but it's got to be better for them than that pink and blue stuff most fairs boast.

At the fair, you can discover curds—squeaky lumps of white, salty, cheddar-flavored cheese. The curds are made from the milk produced by dairy cows staying at the fairgrounds

left: Isabel Karsch, age five, of Barton competes in the lead line class for beginning riders. The horse is named Rodney, and she is led by Monica Aldrich.

above: Congressman Peter Welch poses with a llama.

previous page: The Zipper was a popular ride on the midway.

during the week of the show and are used to make *poutine*, a favorite dish among French Canadians. The recipe? French fried potatoes with gravy and melted cheese.

The mobile milk processing unit, new to the fair in 2010, solved a big problem.

John Simons, a veterinarian and one of the directors of the Orleans County Fair, said milk co-ops stopped accepting milk from any of the fairgrounds in 2009, but farmers could not afford to throw away milk for the week they had milking cows at the fair. With the new mobile processors the fair committee can pay the farmers for milk and sell the curds. "This is exactly what Yankee ingenuity is all about," says former Vermont Secretary of Agriculture Roger Allbee on

the day a new mobile processing unit opened for business.

Dr. Simons said in 2009 there were only nineteen milking cows at the fair. By 2010 the number increased to thirty-five. Vice-president of the fair committee Mike Tetreault says the unit helps educate the public and demonstrate cheesemaking. At the 2010 fair, the unit processed about 100 gallons of milk each day.

County fairs are prime showcases for farmers, who proudly display their best work. It is also a chance for people to meet the farmers and learn more about what it takes to raise the best livestock in the county, make the sweetest maple products, or craft the most beautiful jar of pickles.

at a GLANCE

The Orleans County Fair at Roaring Brook Park

278 Roaring Brook Road Barton, VT 05822
(802) 525-3555
www.orleanscountyfair.net

Caledonia County Fair

1 Fairground Street Mountain View Park Lyndonville, VT 05851
(802) 626-3207
www.vtfair.com

parker pie

The pizza at Parker Pie melts in your mouth. Unusual ingredients and flavor combinations will challenge your taste buds. Maple syrup? Apples? Artichokes and bacon? Give it a try, decide for yourself.

While you are waiting for your pie, take a look around. This place was created from the remnants of an old building. The restaurant's support structure is composed from old beams, and the sheet metal roofing over the bar had an earlier life as an exterior roof.

The atmosphere is funky, solid, family-friendly, and full of energy. Live music by local rock, bluegrass, and jazz players permeates the room. It's the kind of music that makes you want to dance. Occasionally, a band from Brooklyn, New York will play a set; it seems word is getting out about Parker Pie.

The art on the walls is created by locals and curated by West Glover artist Elizabeth Nelson. Depending on the day, you can find watercolor landscapes, oil and acrylic paintings of tractors, portraits, scientific drawings, and photo-

graphs. The sky is the limit and that's because the talent hidden in nooks and crannies in this geographic area is mighty.

On a summer night you will see kids running around the yard, customers getting take-out, and locals sipping beers and enjoying the chance to gossip with their neighbors. If you ride your horse, bike or walk to Parker Pie, you'll get a discount. This incentive is both green philosophy and practical thinking at work: the place was getting so crowded that parking space became an issue.

Which is no wonder. There is a lot to enjoy at this gathering spot, that started when Phil

Young bought Lake Parker Country Store in May 2003. The place had been closed and vacant for about a year and a half. Mr. Young, who had worked in natural food stores and restaurants, decided to buy the building.

The pizza itself was the brainchild of his friend Cavan Meese, who decided to establish Parker Pie in the back room where a post office used to be (hence the logo, which looks a bit like a postmark).

The Parker Pie menu has expanded with the creativity of the good folks who own it and work there. Laura Thompson, in particular, brings a unique

at a GLANCE

The Parker Pie Co.
161 County Road
West Glover, VT
(802) 525-3366
www.parkerpie.com

left: At the back of the new space at Parker Pie the stairs lead to the Village Hall, created out of the old building's attic.

previous page: Founder Ben Trevits tosses a pizza crust while co-founder Cavan Meese looks on.

creativity to the restaurant's special dinners that include a Wednesday "bistro night," and Tapas Thursdays.

Oysters are available on occasion. You might find venison raised at the Hollandeer farm (located by the Canadian border), mushrooms with local cheeses, golden beets, Spanish-style pork loin with paprika, and juniper berries served with roasted butternut squash. For dessert, try the couscous Chambord cheesecake.

Because of its success, Parker Pie has had considerable media attention from outlets near and far, including a mention rare as "best pizza in America" on the nationally broadcast Rachael Ray food show, and Vermont Life, WCAXtelevision. Rick Nichols, a writer for the *Philadelphia Inquirer* known to frequent West Glover in the summertime, wrote an article on the restaurant.

Together, Cavan Meese and Ben Trevits are the two main owners of the business. "We didn't really know this was going to happen," Mr. Meese says about the popularity of the place. He jokes, "People were . . . hungry for it."

Mr. Meese and Mr. Trevits grew up in Glover and have known each other since they were in grade school.

Mr. Meese's love of pizza began in his youth, when he traveled frequently to New York City with his parents. "At some point, when I was a teenager, I started having a pizza obsession."

Mr. Trevits went to New Hampshire College, now Southern New Hampshire University, and studied small business and culinary arts. At school he learned baking and pastry making.

But after a motorcycle accident he decided he wanted to work outside and went into the construction business with a local outfit specializing in fine carpentry, Old School Builders. He was married eight years ago, and he and his wife Marisa have three young daughters.

After about four years building, Mr. Trevits decided he wanted to get back into cooking and joined Parker Pie. Mr. Meese said that at first he thought the space would be just big enough to support a couple of guys making pizza. But the business has grown to the point where it has roughly fifteen employees.

In addition to Mr. Trevits and Mr. Meese, Sam Young and Laura Thompson are part-owners. A group of local people called the Glover Group bought the building from Phil Young.

Make sure to drop by Parker's on Thursdays for music night, organized by Vermonter Howie Cantor. They have no cover charge, but they do pass the tip jar.

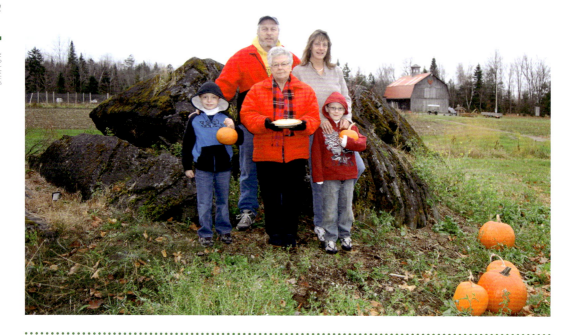

peak view

There comes a night in summer, around the Fourth of July, when the fire-flies take over the field behind my house. The tiny lights flash on and off over the ground, a bioluminescent complement to the stars in the night sky. It's beautiful, completely silent, and always surprising.

The bugs' flashing lights are mating signals. Apparently they work, because there are what appear to be thousands of fireflies in my pasture.

By the Fourth of July the corn is knee-high. Already the days are getting shorter. The first vegetable to ripen is the crispy, spicy, bright red radish. We snack on them while playing cards.

Around the same time, the Bonins' Peak View Farm Stand appears on Route 5 in Barton. They are always the first to offer summer corn, fresh on the cob, picked on the same day they sell it. With real butter and salt, it's extremely tough to beat.

Marcel Bonin plants eight varieties of corn in staggered plantings so some will be ripe from the beginning of the season to the end. Some varieties take just sixty-four days to ripen. "Our longest one is eighty-two days," Michele says. Her favorite is called Trinity. "The kernels are very tiny, and they're snappy."

If you want a pie like the ones your mother or your grandmother used to make, get to Peak View early in the morning. Marielle Bonin makes them and sets them out—still warm—sometimes ten a day, $9 apiece. Apple pie, rhubarb pie, blueberry pie. People know about this, as the desserts are usually gone by noon. "I love

strawberry pie. Plain strawberry pie. That's my favorite," Marielle Bonin says.

When Michele Bonin started learning about gardening from her husband Marcel and father-in-law Germain, she tried planting onion sets upside down. Her father-in-law asked her what she was doing. "Do you know how many people plant onions upside down?" she said to him with a laugh.

"He could pick a flat of raspberries in seventeen minutes," says Michele. A flat is fifteen pints. "A lot of guys can't pick fruit 'cause their hands smush 'em." It takes her more than

twenty minutes to pick a flat. "He was my hero," she adds.

One summer, not long before he died in 2005, Germain Bonin took Michele for a drive in his Toyota pickup truck, describing to her everything she needed to know about each plant in their massive garden. He told her how far to push in the onion sets, when to thin the carrots, how to tell when something is ripe. Her notes that day make up an entire book.

To honor him, Michele and Marcel named one of their sons Schyler Germain. Michele says the boy's grandfather was so proud of him that he used to come over every single morning just to look at the baby.

With a family so committed to their farm, it is not surprising that Schyler and his brother Nicholas don't eat much food from the supermarket. By the end of the gardening season, Marcel and Michele have 300 pounds of potatoes in their basement, forty-seven quarts of frozen corn, and four and a half cases of jars filled with stewed tomatoes in addition to jars of green beans, dilly beans, beets, and beet pickles. The couple also raises six pigs.

In the winter Michele goes to work cutting up meat for Phil Brown in Glover. Mr. Brown

owns Vermont Rabbitry and Brown's Custom Meat Processing. Butchering is another skill that Michele learned from her father-in-law, who owned Orleans Freezer Locker for about twenty years, during about ten of which was a business with a slaughterhouse.

"We used to have people coming from New Hampshire to get their meat cut up," Marielle Bonin says. Germain Bonin retired from the meat business for health reasons. His son Marcel had bought some land in Brownington, after which Germain said, "We need to plant strawberries."

This year Marcel and Michele Bonin planted 22,000 strawberry plants. In a good growing season, strawberries can produce 10,000 pounds of fruit per acre. The first year you clip the blossoms and don't let the plants produce fruit. After that, they produce for three years and are then tilled back into the soil.

Marcel and Michele's farm is popular with local wildlife. "Moose love peas and raspberries," Michele says. One day she saw a beautiful doe with her fawn and called her husband to tell him about it. The next day she saw the two sets of tracks, one big and one little, where the pair had eaten 1,000 heads of

the Bonins' lettuce.

Another time, Michele arrived at the gardens to see something that looked like massive bloodshed. "The deer had eaten every single beet that they could find," and beet juice was everywhere.

She had heard about a trick to keep deer out of a garden that seemed unlikely: twelve to sixteen inches off the ground, string fishing wire tightly around the perimeter. The deer can't see it and run into the wire, and promptly turn back out of fear. She tried it, and it worked.

at a GLANCE

Peak View Farm Stand on Route 5 just south of Orleans is open in the summer and early fall.

(802) 754-6319

left: Some years the Bonins have put out as many as 111 jack-o'-lanterns by their farm stand on Route 5, just south of Orleans Village.

previous page: In back is Marcel Bonin. In front, left to right, are his son Nicholas, mother Marielle, wife Michele, and son Schyler. The barn in the background has a big red strawberry on it, painted by Marcel's sister Carmen Comeau.

above: In this photo are three generations of the Smith family at Highland Lodge. On the couch are Alex and his son Yakumo. Alex's wife Yukiyo is at the piano, his mother Wilhelmina and his daughter Kiya work on a puzzle, and his father David is in the background.

GREENSBORO

Bien Fait Bakery

Bien Fait Specialty Cakes provides the highest quality teacakes, fruitcakes, and specialty cakes delivered right to your door. All of the profits from the bakery are given to provide long-term sustainable funding for Wonder & Wisdom, a nonprofit located in Greensboro, Vermont.

100 Atherton Way
P.O. Box 250
Greensboro, VT 05841
(802) 533-2253
bakery@bienfaitspecialtycakes.com
www.bienfaitcakes.com

Circus Smirkus

Since 1987, this organization has provided a format for youths and adults to collaborate in circus arts. They stage a Big Top Tour with their company of Troupers that tours New England and provide educational programs in the form of in-school residences and summer circus camp.

1 Circus Road
Greensboro, VT 05841
(802) 533-7443

Honey Fountain

The Green Mountain Honey Fountain suffered a bear attack in the spring of 2011, so the business is down to four hives with two more on the way. Raw honey is sold at Smith's Store in Greensboro Bend and the Craftsbury General Store.

Shawn Mercier
312 Highlander Road
Greensboro Bend, VT 05842
(802) 533-2183

Greensboro Historical Society

Works to preserve Greensboro's rich history and educate the community about early settlers. They display an exhibit that changes annually, host programs throughout the year, and sell an array of publications. The museum is free and open to the public.

Open Tuesday, Wednesday and Thursday 10 am to 1 pm, and Saturday 10 am to 12 noon.

Center of Greensboro
Greensboro, VT 05841
(802) 533-2657

Hazendale Farm

Grows certified organic fruits and vegetables and sells them at locations throughout the Northeast Kingdom including Mac's, Hunger Mt., and NECI. At their own farm stand they offer items from local merchants including maple syrup, cheeses, meat, free-range eggs, and bread, in addition to produce.

David Allen and Diana Griffiths
2853 Hardwick Street
Greensboro, VT 05841
(802) 533-9992
info@hazendalefarm.com

Highland Lodge

As this book was going to press, the Highland Lodge in Greensboro had just closed for business after fifty-seven years of the Smith family serving up local foods. The cross-country ski trails will remain open with help from the Smith family, volunteers, and the Craftsbury Outdoor Center. This is just to say thanks to the Smiths for all they did over the years to support the local farmers and pie bakers. The Lodge is for sale.

Jasper Hill
(see page 60)

884 Garvin Hill Road
Greensboro, VT
(802) 533-2566
info@jasperhillfarm.com

Lakeview Inn

This inn has a study center to promote learning about local and regional food products, as well as residential opportunities to promote awareness of the consumption and production of food from small-scale Vermont enterprises.

295 Breezy Avenue
Greensboro, VT 05841
(802) 598-6287
contact@lakeviewinnvt.com

Maplehurst Farm

A small family-run dairy farm
that also produces high-quality
maple syrup.

Peter and Sandy Gebbie
2183 Gebbie Road
Greensboro, VT 05841
(802) 533-2984
sgebbie@excite.com
psgebbie@yahoo.com

Sawmill Brook Farm

A small family-run operation
that raises premium, all-natural
grass-fed Angus beef, registered
Angus breeding stock, and pas-
tured poultry. A member of the
Vermont Fresh Network.

P.O. Box 69
Greensboro, VT 05841
smbangus@yahoo.com

Willey's General Store

Owned and operated by the
Hurst family for five generations,
this local institution sells a bit of
everything—from ammunition to
wine—and was even immortal-
ized in Wallace Stegner's novel
Crossing to Safety.

Open Monday through Friday, 7
am to 5:30 pm, and Saturday and
Sunday 8 am to 5:30 pm.

7 Breezy Avenue
Greensboro, VT 05841
(802) 533-2621
willeys.store@gmail.com
www.vaics.org/stores?store=24

A BRIEF HISTORY OF THE KINGDOM

There is something about the Kingdom that keeps people coming back. It's not surprising that people from all over the world have made the deliberate choice to call the woods and mountains of Vermont their home. Maybe it's the close-knit community, or the verdant expanses and awe-inspiring vistas, but this state has a tight hold on its residents.

The native people of the Kingdom moved with the seasons, following the salmon in streams, the deer in forests, and the promise of crops in summer. For generations before the Europeans arrived, this land was home and harvest for the Abenaki people, known in their language as "People of the East." Little remains of their settlements—only unmarked and overgrown village clearings, woodland paths, and burial sites. But their descendants remain in Vermont, carrying on ancient traditions and culture. Names like Nulhegan, which refers to a group of people known for their deadfall traps along what is now Island Pond, retain evidence of the Abenaki's heritage.

French trappers were the first Europeans to enter Vermont. They moved in from farther north, probing south for new farmland. The hilltop farms and villages they built are still in existence today. Why they chose to build on these pinnacles remains a mystery, although there are many theories. Perhaps early settlers were trying to avoid valley flooding, or the unhealthy rising air of swamps, or maybe these villages were simply a copy of European towns, built on high to prevent enemy invaders.

In any case, by the time the Industrial Revolution came around, settlements moved to the rivers, where abundant water allowed for better mills and factories. Train tracks connected Vermont to Boston and New York, carrying timber and farm products. The state opened up, allowing for commerce, social exchange, and a variety of people and influences that remain there today.

continued on page 94

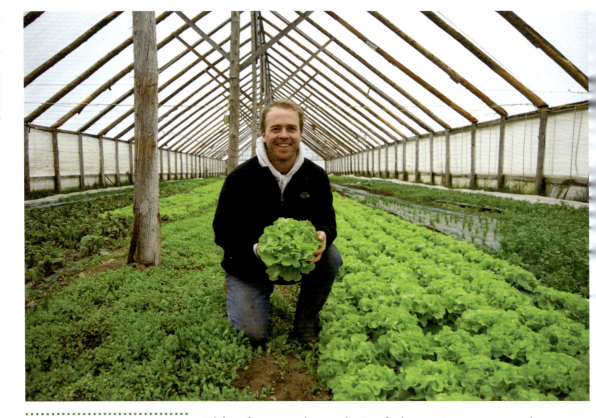

pete's
greens

I like driving through Craftsbury Common and seeing a small pile of horse manure in the middle of the road by Sterling College—fresh, steaming, and wet.

I like it because it makes me think this might be the one town where people actually know the ancient Vermont law, which is still on the books, that gives horses the right-of-way over cars.

Sterling College uses draft horses for logging and farming, and the teams are often seen on the roads of Craftsbury, sometimes with a student at the "wheel," learning how to handle them.

Craftsbury is where I grew up. My parents have roots in Vermont, and our family moved here from the Boston area when I was nine years old. My uncle Elliott Merrick wrote a book

about farming in Craftsbury during the Great Depression called *Green Mountain Farm*. It's still pretty well-read. Once in a while I find a Sterling student who knows the book.

He taught at the stately old Academy building, from which I graduated alongside twelve other students in 1977. It's one of the smallest high schools still in existence in Vermont. There I learned Latin, French, algebra, poetry, Shakespeare, politics and government, cross-country and alpine skiing, gun safety, soccer, sailing, how to make jewelry from silver and a chess set from clay, and how to write.

What's important to people

in Craftsbury, whether they have lived in town for seven generations or have just moved here, is the environment and the community. It's not that the town doesn't ever fight; in fact, Craftsbury people fight quite a bit. They fight about things they care about. But underneath all that, their shared passion for these core values is understood.

When I went off to college at nearby Lyndon State, a guy once told me I looked like I came from Craftsbury. I knew what he meant right away: no makeup, red-cheeked, a wool sweater, L.L. Bean boots. I took it as a compliment.

The deep sense of com-

munity that pervades the Craftsbury area was tested when the main barn at Pete's Greens, which was full of food and equipment, burned to the ground. There was some insurance, but not enough to compensate for the loss. As it turned out, the strength of Pete Johnson's community went way beyond the town line and even passed state borders. As news of the fire spread rapidly, people started coming up with ideas to raise money to help rebuild.

Pete Johnson decided to accept these donations but consider them a loan. Over time the money will be repaid to help all Vermont farmers in times of distress. The money will go into a revolving fund called the Vermont Farm Fund, handled by the Center for an Agricultural Economy.

Pete Johnson grew up in neighboring Greensboro. He was about twelve years old when he first put up a farm stand selling vegetables he'd raised. There's an enterprising young guy, I thought.

Mr. Johnson found fertile ground in Craftsbury, where he eventually moved and bought a farm (a former dairy) to build his business, Pete's Greens.

Pete's Greens has 350 regular customers—people who subscribe to a CSA plan. CSA stands for Community Supported Agriculture, and it's a system that guarantees members a box of vegetables each week, while guaranteeing the farmer some steady, reliable income.

Mr. Johnson raises 40,000 pounds of beets, 70,000 pounds of potatoes, and 50,000 to 60,000 pounds of greens. Recently, his business has grown by fifteen to twenty percent a year in gross sales. But for him, that's plenty of growth per year. He doesn't want the business to grow so fast he loses control over quality.

"It's not like you're just making widgets," he says. He has seven full-time employees and thirteen in the growing season.

A system of greenhouses extends the short Vermont growing season. Most of the greenhouses are not heated, but the warmth from the sun makes a big difference in farmers' ability to plant crops earlier in the spring and keep them from freezing later in the fall.

Mr. Johnson knows the benefits of a greenhouse. At Middlebury College, he made a solar greenhouse for his senior thesis. At Pete's Greens, which he started in 1995, he uses recycled vegetable oil to heat the space that does need it.

"The future of eating locally in Vermont is not heating thousands of acres of greenhouses," he told a tour group in 2008. He says it just doesn't make sense to burn energy to heat the greenhouses in order to get lettuce in February. It would use so much energy you might as well truck in the produce.

By the middle of March in Vermont, you can grow all the greens you want in an unheated greenhouse. In the winter, CSA customers might find some sprouts grown under lights as a bit of green to supplement the beets and other root crops that are dug in the late fall and stored for the winter. Customers who sign up for extra local products will get five pounds of oats and some delicious Jasper Hill clothbound cheddar made in the cheese caves in Greensboro.

"There will be something green all the time," Mr. Johnson promises.

at a GLANCE

Pete's Greens are available in the summer from a stand at the farm, in the center of Craftsbury Village. Pete's Greens can be found at the Montpelier farmers' market, the Buffalo Mountain Co-op in Hardwick, and Willey's General Store in Greensboro.

266 S. Craftsbury Road
Craftsbury, VT 05826
(802) 586-2882
tim@petesgreens.com
amy@petesgreens.com
www.petesgreens.com

previous page: Pete Johnson of Pete's Greens holds up a head of lettuce in one of his greenhouses.

above: Outside view of the farm. (Photo by Eleanor Baron.)

ploughgate creamery

Ploughgate Creamery cheeses are soft cheeses, like Brie. They are smooth, rich, creamy, and some are a bit tangy. Cheesemaker Marisa Mauro makes a variety called Willoughby that has a rind washed with Honey Garden Apiaries mead, or occasionally, with ice cider or microbrewed beers.

Her cow's milk camembert, Hartwell, won the blue ribbon at the American Cheese Society competition.

Ms. Mauro is an incredibly talented cheesemaker, in spite of the fact her company has only been in business since 2008. She is so young that she sometimes get mistaken as some kind of a spokesmodel at cheese tasting events. People ask her about the cheesemaker and are surprised when she

reveals that she is, in fact, the person in charge.

Ms. Mauro grew up in Dorset, Vermont. She attended Craftsbury's Sterling College for a year, but left to start Ploughgate in a leased building in Albany with a good friend, Princess MacLean (who has since moved on to another agricultural enterprise). Both wanted to be farmers and to start with cheesemaking. "I've just been working on farms that

produced cheese ever since I was sixteen," Ms. Mauro says.

She still holds onto her dream to become a farmer, but for now, the cheese business occupies all of her time.

Having just returned from a trip to the Slow Food convention in Italy, Ms. Mauro says she was inspired and excited by the event and the people she met. Ms. Mauro first heard about the Slow Food movement when she was milking goats for a farmer

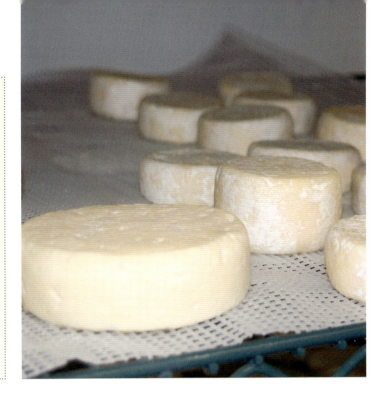

in California, who was planning to attend. "When I first found out about it, I was nineteen and I had to watch the farm for him," Marisa says.

Partway through the trip, the farmer called to see how everything was going. She reported that things were fine, but just after she hung up the phone the refrigeration system broke down. She realized she didn't have a telephone number where she could reach her boss.

But she worked it out. "I didn't lose any milk or any cheese," she says.

Ms. Mauro has been working extremely hard lately, so it was a great treat to get away and attend the Slow Food Conference in Italy. "I got to work on an olive farm and help with the harvests," she says.

Ms. Mauro went to Italy for the first time with the Kehler family—relatives of the owners of Jasper Hill in Greensboro.

At the time, she was fifteen and working as a nanny for their kids. That's how she met the family. These days, she takes her cheese to the Jasper Hill cellars for aging.

Area cheesemakers are extremely supportive of Ploughgate. Ms. Mauro says the Vermont Cheese Council has been helpful, as have Jasper Hill, Bonnieview, and Laini Fondiller of Lazy Lady cheese. Nice neighbors.

editor's note: Sadly, as *Kingdom's Bounty* went to press, Ploughgate Creamery caught fire. Marisa Mauro is currently looking for a new premises.

above: Ploughgate cheeses aging on the shelves.

left: These are some samples of Ploughgate cheese varieties, fully aged.

previous page: Marisa Mauro of Ploughgate shows off some new cheeses that have yet to age and ripen.

quimby country

When I look at maps, my eyes are always drawn to the unmarked areas, the empty spaces on the map, where there are no cities or roads. These places are rich with forests, lakes, mountains, fresh air, moose, bears, other wildlife, and sometimes old logging roads to explore. Take, for example, Essex County.

Aunt Maude Lund was the town clerk in tiny Granby (population eighty-six) for more than thirty years. She was one of the people responsible for providing electricity to the towns of Victory and Granby in 1963.

At the time, the power company said it wasn't worth extending the power lines to so few customers. In response, the townspeople decided to hold a festival to raise the money themselves. The men built the Cook-Shack, and the women cooked a meal. The event was called Holiday in the Hills, and it worked. The towns raised

enough money to fund the cost of electricity.

Aunt Maude died in 1999 at the age of eighty-seven. She never learned to drive a car, but she served her town, raised her family, and worked in the legislature. If she needed a ride, people in town would drop what they were doing to lend a hand. She always gave them a few dollars for their kindness, because the last thing she wanted to be was a freeloader.

Aunt Maude was a hunter and gardener, and she crafted her family's quilts and churned butter to sell to the neighbors.

The same year that Aunt

Maude died, the federal and state government and a private timber company worked out a deal to conserve 133,000 acres in Essex County, which were formerly owned by the Champion paper company. The plan ensures that Essex County will remain one of those wild and empty places on the map.

Ray Wojcikewych is the general manager of Quimby Country, a 100-year-old lodge in Averill. The lodge owns 1,200 acres, including the sixty-acre Forest Lake. The main lodge is on the shore of Forest Lake, and Great Averill is a short walk away. Quimby

Country owns two beaches on Averill.

Mr. Wojcikewych says people who come to Quimby Country for the first time wonder what national park it is. But this land isn't in a park. It's owned by a corporation established when Hortense Quimby died.

I did not know Hortense Quimby, but from the descriptions I've heard, I imagine that she was something like Aunt Maude. Her father, Charles Quimby, founded Quimby Country in 1894 as a hunting and fishing lodge on Forest Lake near the Canadian border. From all accounts it was Hortense who ran the place until 1965. She had lots of horses and made riding trails all over the property.

"She didn't have any heirs," Mr. Wojcikewych explains, and no one to leave the property to. But some of the regular guests who had been coming to Quimby Country every summer for decades were not prepared to give it up. So they bought it.

Currently, there are 4,000 shares in the corporation. Some people own 150 shares; a few families own shares together. There is a twelve-member board of directors that sets policy, and Mr. Wojcikewych carries out these policies and runs the day-to-day operations from May to November, seven days a week.

A fishing guide by trade, Mr. Wojcikewych was working in Alaska when he first heard about Quimby Country. Many of the guests are fly fishermen and hunters, and people are welcome to bring dogs—bird dogs and pets alike. "We've survived two world wars and the Great Depression. I don't think a poodle is going to bring us down," he says.

The menu at the resort

features pheasant pot pie and venison osso buco, a tomato-based venison stew made from shank meat sourced at nearby Hollandeer Farm. Every Friday, there is a lobster bake on the beach with lobster brought in that morning directly from the cold waters of Maine.

Quimby Country also boasts a rifle range and a trap shooting range.

On Wednesdays, they host Quimbledon—a weekly tennis tournament on the 100-year-old clay court.

Mr. Wojcikewych tries to keep the facilities maintained, while changing as little as possible. Some of the families have been coming for over sixty years, and they like it the way it is. "Trust me, the guests let me know if I've moved a picture."

Quimby Country has internet access, but no cell phone coverage and no television. Mr. Wojcikewych says he's pretty sure he knows what would happen if he put up a flat screen television in the main living room. "I'd be hung from the flagpole," he says.

Big Averill has lake trout, and Lake Seymour nearby has small-mouth bass. The Connecticut River has trout, and Norton Pond has northern pike. The woods have moose, bear, and some whitetail deer.

Word of warning. Essex County is moose country. If you drive up to Quimby Country in Averill, be careful. Moose have a tendency to walk out on the roads in front of cars, and if they do it at night, they're very difficult to see.

at a GLANCE

For more information, contact the general manager:

Ray Wojcikewych
(802) 822-5533
quimbyc@together.net
Mailing address:
Quimby Country, P.O. Box 20
Averill, VT 05901

Physical address:
1127 Forest Lake Road
Averill, VT 05901
www.quimbycountry.com

above: Nearby is a hike to the top of Brousseau Mountain, where there is a great view of the lake. (Photo by Alan Cattier, courtesy of Quimby Country)

previous page: The main lodge at Quimby Country (Photo courtesy of Quimby Country)

rabbit hill inn

The chefs at Rabbit Hill Inn love to play with their food — creating innovative recipes from local ingredients.

Leslie and Brian Mulcahy first came to the Rabbit Hill Inn for a vacation in 1992. They had never been to an inn but loved it right away. As it happened, the owners at the time were looking for assistant innkeepers who could eventually take over the business.

The Mulcahys found they loved the innkeepers' life, which is fully demanding but rewarding, and always interesting. They bought the inn in 1997 and, since then, have done extensive renovations and upkeep to the inn buildings, some of which date back to 1795. They have made some of the rooms larger and added whirlpools, fireplaces, and other amenities to develop the high-end details that draw new customers of all ages and keep repeat customers coming back for more. There are no televisions in the place, but wifi is available.

Fine dining is part of the overall experience. Executive chef John Corliss and sous chef James Pinkham change the menu daily based on what ingredients are available at local farms. In particular, the chefs work with Harvest Hill Farm in Walden and Chandler Pond Farm nearby. The inn doesn't have storage space for everything the chefs use over the winter months, so the farms store these for the inn.

"They're constantly talking about what's available today and how can they play with it," says Ms. Mulcahy about the chefs.

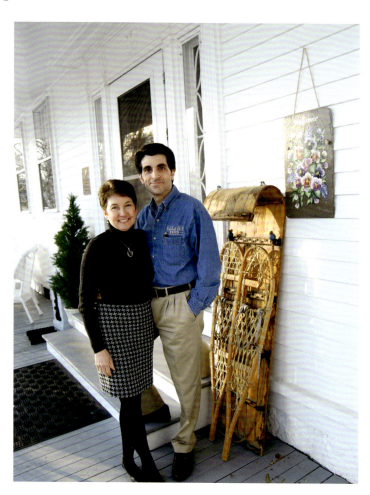

Chef John Corliss prefers local ingredients and says they are not necessarily more expensive. The inn buys local pork from a farm that slaughters fourteen pigs a week as opposed to hundreds that would be processed by a large pork producer.

"They're raised in a more responsible manner, and they're raised right here in Vermont,"

he says.

Sous chef James Pinkham worked for High Mowing Seeds in Wolcott before coming to work at the inn. On the day of my visit, he was making kimchi, an Asian dish made of spiced fermented cabbage and other vegetables. He was using local carrots, cabbage, and garlic. Spices included ginger, chili, fish sauce, and soy sauce.

Chef Corliss says when they put this dish on the menu, they will call it 'spicy cabbage' instead of kimchi. Not everyone knows what kimchi is, and he doesn't want to scare people away from trying it.

"Sometimes you have to nudge people out of their comfort zone." The chef loves trying new recipes. For that reason, and because of the changing availability of certain local ingredients, the menu at the Rabbit Hill Inn changes constantly.

One example of an unexpected dish on the menu is Moxie glazed sweet potato gnocchi with pomegranate. Another is bone marrow custard. The latter is a popular item with people visiting from cities where it is served more often. For those feeling less adventurous, there are the beef sirloin strip and pan roasted chicken.

The constantly changing menu keeps things interesting, Chef Corliss mentioned.

"I think people can tell when we're excited," he says.

at a GLANCE

Rabbit Hill Inn owners Leslie and Brian Mulcahy offer luxurious rooms and elegant fine dining in a beautiful country setting. Named among the Top Small Resorts in the U.S. by Condé Nast Traveler Magazine *and one of the Top Ten Inns in the U.S. by* Travel and Leisure Magazine *in 2011.*

48 Lower Waterford Road Lower Waterford, VT 05848 (802) 748-5168 leslie@rabbithillinn.com www.rabbithillinn.com

above left: A spectacular white Christmas tree is reflected in the mirror in one of the front rooms at the inn.

left: John Corliss, right, is the executive chef at the Rabbit Hill Inn. On the left is sous chef James Pinkham.

previous page: Leslie and Brian Mulcahy on the front porch of the Rabbit Hill Inn.

Down to Earth Worm Farm / New Leaf Designs Eclectic Nursery & Gardening Systems

Worm composting, casting, and wisdom. The adjacent nursery sells a range of houseplants, perennials, and flowering and fruiting trees. Handmade bird feeders, garden whimsies, fine hand-crafted furniture, electric guitars, and silver jewelry are also available for purchase.

281 The Bend Road
Greensboro Bend, VT 05842
(802) 533-9836
downtoearth@vtlink.net
www.downtoearthwormfarmvt.com

Hill Farmstead Brewery

(see page 58)

403 Hill Road
Greensboro Bend, VT 05842
(802) 533-7450
www.hillfarmstead.com

Woods Edge Farm

A small, organic farm commited to providing clean, attractive products. Woods Edge grows a variety of fruits and vegetables, including asparagus, brussel sprouts, several types of peas and potatoes, raspberries, and yellow transparent apples.

39 Swamp Road
Greensboro Bend, VT 05842
(802) 533-7455
info@woodsedgefarm.org

Guildhall Village General Store

Guildhall, VT 05905
(802) 626-3713

Sterling College students enjoy an autumn day on Craftsbury Common. (Photo courtesy of Sterling College)

Maidstone State Park

The most remote of Vermont's state parks, set along Maidstone Lake, which was carved by glacial ice and offers good lake trout and salmon fishing. The campground has forty-four tent/trailer sites and thirty-seven lean-tos in addition to play areas, hiking trails, and a swimming beach.

Open daily from 10 am to 9 pm (or official sunset).

4858 Maidstone Lake Road
Guildhall, VT 05905
Toll-free: 800 658-6934
Summer: (802) 676-3930
Winter: (802) 479-4280

Agape Hill Farm

This family-run llama farm gives tours and trail walks with their animals. $20 per person for trail walks, $10 per person for farm tours. Call for more information and reservations.

Ed and Nancy Kish
618 Houston Hill Road
Hardwick, VT 05843
(802) 472-3711
enkagape@yahoo.com
info@agapehillfarm.com
www.agapehillfarm.com

Buffalo Mountain Food Cooperative and Café

This co-op lives by the motto "food for people, not for profit," integrating and supporting local and sustainable enterprises. They sell organic milk, eggs, local produce, bread, whole grains, meat and seafood, organic coffee, herbs, and crafts by local artisans. Open to the public, you can join for annual dues of $12, which gets you a two-percent discount on all purchases. Check out their café, which is located upstairs.

Open Monday through Friday 9 am to 7 pm, Saturday 9 am to 6 pm, and Sunday 10 am to 4 pm.

The café is open Monday through Friday 9 am to 3 pm, and Saturday 9 am to 1 pm.

P.O. Box 336, Main Street
Hardwick, VT 05843
(802) 472-6020
buffalo1@vtlink.net

Caledonia Spirits

Caledonia Spirits produces mead and fruit wines using locally sourced berries and honey. Varietals include Vermont Black Currant, Wild Maine Blueberry, Melissa Sparkling, Traditional Mead, and Melody Dessert wine.

Log Yard Drive
P.O. Box 1249
Hardwick, VT 05843
(802) 472-8000
todd@caledoniaspirits.com

Center for Agricultural Economy

Founded in 2004 by Andrew Meyer, the center brings together the resources needed to develop and create sustainable resources and programs for local farmers. Recent projects include the creation of an incubator space for Vermont food entrepreneurs and a ten-year strategic plan for the Farm to Plate initiative.

41 South Main Street
Hardwick, VT 06843
(802) 472-5840
center@harwickagriculture.org
www.hardwickagriculture.org

Claire's Restaurant

(see page 28)

41 South Main Street
Hardwick, VT 05843
(802) 472-7053
newvermontcooking@yahoo.com

Connie's Kitchen

In business since 1991, Connie's specializes in homemade baked goods made fresh from scratch daily. Popular items include cookies, pies, donuts, breads, muffins, cakes, and turnovers.

Open daily from 7 am to 5 pm.

Terry Coolbeth
Old Hardwick Inn
Hardwick, VT 05843
(802) 793-7030
stcool9906@comcast.net

Dolly Gray Orchard

A dozen varieties of apples are available at Dolly Gray Orchard for people to pick their own, from the middle of September through Columbus Day weekend in October each year. The orchard has Macintosh, Cortland, Honey Crisp, and a few antique varieties as well.

Guy Patoine
1112 Dutton Road
Hardwick, VT 05843
(802) 472-5797

Galaxy Bookshop

Galaxy Bookshop is an independently owned bookstore catering to the specific needs of Vermonters. Find books here you can't get anywhere else, including works by local authors Reeve Lindbergh and Bill McKibben.

7 Mill Street
Hardwick, VT 05843
(802) 472-5533
galaxy@vtlink.net
www.galaxybookshop.com

Hardwick Historical Society

Hardwick Depot
Hardwick, VT 05836
(802) 563-2508

Hardwick Town House

The Northeast Kingdom Arts Council revived the former opera house in 2001. It is now the scene of town meetings, concerts, plays, and other community gatherings.

127 Church Street
Hardwick, VT 05843
(802) 472-8800
www.nekarts.org

Heartbeet Lifesharing

Heartbeet is a vibrant lifesharing community that provides housing and activities for adults with developmental disabilities, interweaving social and agricultural practices. Community members live in extended family households that form a supportive environment.

Hannah Schwartz
218 Town Farm Road
Hardwick, VT 05843
(802) 472-3285
info@heartbeet.org

Highfields Center for Composting

Highfields is committed to leveraging the power of composting to help farms and whole communities capture and recycle organic

An early September harvest for Sandiwood Farm (Photo courtesy of Sandiwood Farm)

continued on page 100

tamarlane & freighthouse

The Freighthouse restaurant in Lyndonville gets a lot of its food from the family farm. A few miles up the road, Tamarlane Farm grows beef for burgers and steaks, potatoes for French fries, and much more.

"In the summer, especially, we can use a lot of our own vegetables," says Eric Paris, the farmer at Tamarlane.

The Freighthouse, located in the railroad station in the middle of town, is a restaurant, ice cream shop, gift shop, and museum. One weekend in December each year kids and adults can take a train ride to pick up Santa Claus, which takes one hour and forty-five minutes round trip.

Posters with old advertisements for farm products like "Carnation Milk, from contented cows," line the stairway walls that lead up to the shop.

The shop has books about Lyndon's history, Grandpa's pine tar soap, videos about big game and rabbit hunting, wooden spoons made by a tree farmer in nearby Browning-ton, and jam made at a farm in South Wheelock.

"The greatness of a nation

can be judged by the way its animals are treated," says a quote by Mahatma Gandhi that graces the Freighthouse menu.

Tamarlane Farm has taken its commitment to local food a step farther by making connections with local schools and hospital to provide local meat and vegetables. Locals can join a buyer's club and buy organic foods in bulk (with others) to save money.

"December and January are

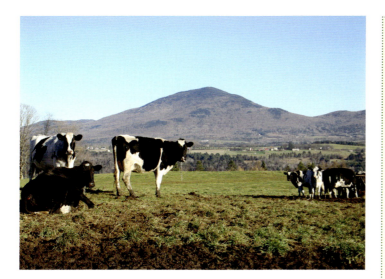

at a GLANCE

Organic dairy farm and restaurant featuring food grown right on the family's farm in addition to neighboring farms.

Tamarlane Farm
2586 Pudding Hill Road
Lyndonville, VT 05851
(802) 626-3265

The Lyndon Freighthouse
1000 Broad Street
Lyndonville, VT 05851
paris@kingcon.com
www.thelyndonfreighthou
se.com

To call the store and restaurant, call (802) 626-1174 or -1400

above: Holstein cows at Tamarlane Farm enjoy a lovely view of Burke Mountain.

previous page: Bonnie Ott moves potatoes, freshly dug from Tamarlane Farm, into storage.

the only two months of the year that you really can't garden," says Mr. Paris, as he and his son-in-law frame a greenhouse. To increase the temperature of the greenhouse without adding outside heat sources, he's working on a two-layered system for the coldest times—a greenhouse within a greenhouse. It's a concept he read about recently in an Elliot Coleman book called *The Winter Harvest Handbook.*

Mr. Paris now farms organically because he believes in it. The soil and the animals are healthier. Before the farm switched, the cows often had foot rot and mastitis, an udder disease. Now, they don't. They have one cow named Polly who is twenty years old. Cows don't usually live that long. "She's a special cow, and she's a pet," he says affectionately.

Mr. Paris sells raw milk from his farm. Raw milk is not homogenized or pasteurized, and selling it has been a controversial practice. People who sell raw milk must include a warning label saying that it may contain harmful bacteria that can cause illness.

Mr. Paris recommends anyone who is considering buying

raw milk to take a good look around at the farm to see that the place is reasonably clean.

All farmers are required to have tests done for somatic cell counts, and the consumer can ask to see that chart. A high cell count parallels an infection of some sort. Customers who are really interested in trying raw milk should do some homework, he recommends, about what those cell counts mean.

Most of the Paris family's raw milk customers are on a weekly list and pick up their milk regularly.

Tamarlane Farm has a total herd of seventy Holstein cows. Eric Paris and his wife Cathy milk twenty-five cows, but Mr. Paris says he expects to be milking at least thirty-five by springtime.

The family also grows barley instead of buying grain. "We haven't bought grain for three years," Mr. Paris says, making an exception for the little grain he buys for very small calves.

Tamarlane Farm grows lots and lots of potatoes. One acre alone can produce 10,000 pounds of them! Mr. Paris says, "The whole secret to organic

crops is rotation." If you move the potatoes far enough from where they were growing the year before, the potato beetles are less likely to walk their way.

Mr. Paris has lived on Tamarlane Farm all his life. His parents bought the place in 1956. His son Ben, daughter Bonnie Ott, and son-in-law Nicholas Ott all pitch in and help out with the family dairy business.

Bonnie spends most of her time at the restaurant but can sometimes be found at the farm, helping dig potatoes.

The house was built in 1858, and the main part of the barn was built in the 1860s. Mr. Paris' parents added to it. "We still call it the new barn, but they built that barn in the early '60s."

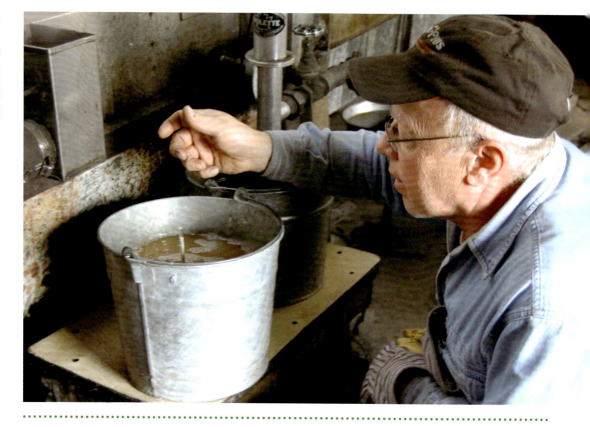

taylor's maple

One night in April, we heard the peep frogs for the first time. That sound always makes me stop and feel grateful to have made it through the winter.

This year, the frogs were two weeks early. Is that a sign of global warming?

Barefoot in the cold mud with a cup of coffee, I look around at the spears of green in the perennial garden, the pussy willows, the greening grass, hear the birds' crazy, wonderful morning chirp and clatter, and soak it all in.

It seems the earliest sign of spring comes earlier every year, when the sap in the maple trees starts to run and the rich smell of new green rolls in.

There are 2,000 maple sugarmakers in Vermont today. The season starts in February. Sometime late in the month, a snowstorm comes along that brings big flakes drifting down quietly. We call this 'sugar snow,' because it means it's time for maple sugaring.

In the woods, a circle of melting snow appears around the base of the maple trees. Warm days and freezing nights create the perfect conditions. The sap runs, and the sugarmakers run even harder.

Sugaring is hard work, but

it's hard to hate it outside in springtime as things melt. If the sugarmaker works with buckets, they do what's euphemistically called gathering. Gathering involves driving from tree to tree with a tractor and a big tank, grabbing the buckets off the spouts on the tree and dumping the sap into the big tank. Then, the sugarmaker hauls the tank back to the sugarhouse for boiling.

Boiling maple sap gives off an incomparable scent. The taste of fresh, warm maple syrup eaten with a homemade

at a GLANCE

The Taylor family sugaring operation is in West Glover. Maple syrup is available at Taylor's Automotive on Route 16 just north of Barton Village. Many members of the family work at the garage as well as help with sugaring.

(802) 525-3456

left: Richard Taylor holds up a tool used to grade maple syrup. His syrup from this year is in the second jar from the left, which is even lighter than the lightest table grade, called fancy or light amber.

above: Francis, his wife Helene, and his father, Richard Taylor, stand by the Ford tractor they use to gather sap at their Albany sugarhouse. The Taylors have been sugaring in these woods since 1965.

previous page: Francis Taylor checks the density of the syrup he's making. The Taylor tradition is to make syrup slightly denser than required, which gives the customers a bit more sweetness for the money when they buy a gallon.

doughnut is, quite simply, as good as it gets.

Driving around the Northeast Kingdom, one can hardly pick a road that doesn't have a sign that reads "Maple Syrup for Sale." If you happen to be in Barton, stop in at Taylor's Automotive. You can get your car fixed and try some incredible syrup, both at reasonable prices, from a delightful family.

"This has got to be the longest run that I've ever seen that we haven't got a storm," says Francis Taylor one Friday in the spring. Mr. Taylor repre-

sents the second generation of a four-generation family operation in Albany. He starts boiling on Town Meeting Day—the first Tuesday in March.

Vermont is the largest U.S. producer of maple syrup. According to the United States Department of Agriculture, Vermont's sugarmakers lead the nation for production with 1,140,000 gallons produced in 2011. The entire United States produced 2,790,000 gallons.

The Taylors do not lack help. On the first day they boiled, there were thirty-four

family members and friends on hand to help.

"It's spring fever," Francis Taylor says. "You'd better believe it."

Highfields Center for Composting

(continued from page 95)

 nutrients as the under-pinning to sustainable food systems. This concept supports the desire of rural communities to rebuild their economic and ecological health through strong, secure, and revitalized agricultural systems to meet their own food needs.

P.O. Box 503
Hardwick, VT 05843
(802) 472-5138
tom@highfieldscomposting.org
www.highfieldscomposting.org

North Hardwick Dairy

2703 Bridgman Hill Road
Hardwick, VT 05843
(802) 472-8889
northhardwickdairyfarm.com

Sunshine Acres

The largest greenhouse and garden center, Sunshine carries winning annuals, bedding plants, perennials, trees, flowering shrubs, garden mums, Christmas trees, wreaths, and poinsettias.

Hopkins Hill Road
Hardwick, VT 05843
(802) 472-8225

Vermont Natural Coatings

P.O. Box 512
180 Junction Road
Hardwick, VT 05843
(802) 472-8700
www.vermontnaturalcoatings.com

Vermont Soy

P.O. Box 401
180 Junction Road
Hardwick, VT 05843
(802) 472-8500
www.vermontsoy.com

HYDE PARK

Applecheek Farm

This certified organic farm produces dairy, grass-fed beef, humanely-raised veal, pasture-raised poultry, raw milk, and emu oil. It is operated under the philosophy of dignity, local economy, optimal nutrition, and sustainability. Call for information about farm tours.

567 McFarlane Road
Hyde Park, VT 05655
(802) 888-4482
applecheek@applecheekfarm.com

IRASBURG

Log Cabin Farm

Newly established, this farm seeks to reanimate neglected hay fields into organic vegetable farms, with the aim of sustaining a family and with a little extra to take to the local farmers' market.

3112 Barton Road
Irasburg, VT 05845
(802) 673-6441

Seslar Farm

Seslar Farm is a thirty-acre organic hay farm that sells square and round bales to other farms.

Max Seslar
3223 Route 5
Irasburg, VT 05845
(802) 754-6387

Warebrook Festival

A summer festival set amidst a 450-acre working dairy farm that brings contemporary concert music to the NEK every summer in mid-July. Warebrook is committed to informing the public through lectures by composers and first-rate programming.

Sara Doncaster
276 Hillandale Road
Irasburg, VT 05845
(802) 754-6335
saracomposer@hotmail.com

ISLAND POND

Brighton State Park

Located on the shores of Spectacle pond, this wild, remote landscape is filled with mountains, running streams, and clear lakes suited to hunting and fishing. The park offers five cabins

Sugar on snow (Photo courtesy of Jed's Maple)

High Mowing Seed Packets

and sixty-one tent/trailer sites, including twenty-three lean-tos. Hot showers are available.

102 State Park Road
Island Pond, VT 05846
Toll-free: (800) 658-6934
Summer: (802) 723-6205
Winter: (802) 476-0181

Chisel & Saw

Steve Stacey displays and sells his unique chainsaw carvings.

Open May through October.

Route 114
Island Pond, VT 05846
(802) 723-4915

Clyde River Outfitters

This outing goods store carries an array of firearms, and hunting, fishing, and fly fishing equipment in addition to camping supplies, clothing, footwear, and home decor. They offer guide services.

10 Cross Street
Island Pond, VT 05846
(802) 723-6500

Island Pond Historical Society & Museum

A historical society occupies the second floor of the restored railway station and displays a permanent collection of photographs, railroad memorabilia, uniforms, and other items.

Open July through September, Saturday 10 am to 2 pm, and by appointment.

Canadian National Railway Station, 2nd Floor
Main Street
Island Pond, VT 05846
(802) 723-4345

Island Pond Town Depot

P.O. Box 135
Island Pond, VT 05846
(802) 386-2117
www.islandpond.com

JAY

Jay Peak Resort
(see page 64)

4850 VT Route 242
Jay, VT 05859
(802) 988-2611
www.jaypeakresort.com

LOWER WATERFORD

Rabbit Hill Inn
(see page 92)

48 Lower Waterford Road
Lower Waterford, VT 05848
(802) 748-5168
leslie@rabbithillinn.com
www.rabbithillinn.com

LUNENBERG

Biz-z-Bee Farm

This farm specializes in blueberries with 1,200 blueberry plants. The farm also sells tomatoes in an extended season, thanks to nine greenhouses. Most of the produce is sold at farmers' markets and some blueberries sell for mead production. Biz-z-bee also has an acre of apple trees and about ten bee hives.

Tom Cantin
1346 Colby Road
Lunenburg, VT 05906
(802) 892-7731
bizbee@fairpoint.net

LYNDONVILLE

Bag Balm Headquarters

Home of the iconic salve company. Bag Balm developed their product in 1899 to soothe irritation on cows' udders after milking. Great on human hands, too.

P.O. Box 145
184 Williams Street
Lyndonville, VT 05851
(802) 626-3610
www.bagbalm.com

listings

HARDWICK HYDE PARK IRASBURG ISLAND POND JAY LOWER WATERFORD LUNENBERG LYNDONVILLE

Café Sweet Basil

This cozy café offers food, drink, and entertainment. They also cater events from business lunches to cocktail parties. Check out the live music Wednesday nights.

Open for lunch Wednesday through Friday 11:30 am to 2 pm, and for dinner Tuesday through Saturday 5:30 pm to 8:30 pm.

32 Depot Street
Lyndonville, VT 05851
(802) 626-9713
drobarts@hotmail.com

Caledonia County Fair
(see page 78)

Mountain View Park
Lyndonville, VT 05851
www.vtfair.com

Juniper's Restaurant at the Wildflower Inn

2059 Darling Hill Road
Lyndonville, VT 05851
(802) 626-8310
info@wildflowerinn.com
www.wildflowerinn.com
www.juniperrestaurant.blogspot.com

The Lyndon Freighthouse

1000 Broad Street
Lyndonville, VT 05851
(802) 626-3265
(802) 626-1400
paris@kingcon.com
www.thelyndonfreighthouse.com

Meadowbrook Farm

Ray Clark raises registered milking Devons for breeding stock on his farm and is a director on the American Devon Cattle Association. His ancestors have been on the property since 1627, and their heard most likely traces back to the Mayflower. The farm sells pumpkins in the fall.

Ray Clark
1429 Red Village Road
Lyndonville, VT 05851
(802) 626-8306

Speedwell Farm

Grows and sells vegetables, beef, pork, eggs, and milk available at the Lyndon Farmers' Market and direct from the farm.

267 Couture Flat
Lyndonville, VT
(802) 535-9677
speedwellfamrs@gmail.com

Tamarlane Farm
(see page 96)

2586 Pudding Hill Road
Lyndonville, VT 05851
(802) 626-3265

Trout River Brewery

Brews fresh, local, and unfiltered beers in a wide variety of flavors. They rotate six to ten beers on tap and serve gourmet, hand-tossed pizza. Trout River beer is available at stores and bars across northern Vermont. Look for the unique hand-carved trout tap handles.

Open Fridays and Saturdays 4 pm to 9 pm.

Route 5
Lyndonville, VT 05851
(802) 626-9396
info@troutriverbrewing.com
www.troutriverbrewing.com

MONTGOMERY

Montgomery Adventures

A four-season adventure guide service in Northern Vermont that offers outdoor tours and recreation for the whole family. Some of their adventures include dog sledding, kayaking, snowshoeing, camping, boat rentals, lakeside barbecues, and more.

262 Deep Gibou Road
Montgomery, VT 05470
(802) 370-2103
mthavensledogs@yahoo.com
www.montgomeryadventures.com

MORGAN

Seymour Lake Lodge

A country inn nestled in the mountains offers water activities and an antique gift shop.

28 Valley Road
Morgan, VT 05853
(802) 895-2752
www.seymourlakelodge.com

MORRISVILLE

The Bee's Knees (Associated with the Do Nothing Farm)

This casual dining spot is committed to supporting local farmers, food producers, musicians, and artists. The café features local and vegan options on their menu and sponsors live music every night and hosts monthly art exhibits.

Open Tuesday through Sunday 7:30 am to 10 pm.

Sharon and Jay Caroli
82 Lower Main Street
Morrisville, VT 05661
(802) 888-7889
sharon@thebeesknees–vt.com
jay@thebeesknees–vt.com

NEWPORT

Le Belvedere

On the waterfront in the Emory Hebard State Office Building, Le Belvedere offers fine dining in a beautiful setting with spectacular views of Lake Memphremagog. Chef Jason Marcoux and the staff have created an innovative menu of entrées and appetizers. Many items include Vermont ingredients. An extensive list of martinis and house-designed cocktails feature beautiful and intriguing combinations with fruit, milk, and maple syrup as part of the palette. Sushi is available on Thursdays.

100 Main Street
Newport, VT 05855
(802) 487-9147

East Side Restaurant

Popular with locals and visitors alike, this restaurant and pub is famous for its hearty comfort food. Set along the shores of lake Memphremagog, East Side offers banquet services in their Dancing Sail room, hosting weddings, birthday celebrations, or special occasion dinners.

47 Landing Street
Newport, VT 05855
(802) 334-2340

Goodrich Memorial Library

Along with its thousands of volumes, the library houses numerous photos, paintings, and memorabilia of the area's past, along with a taxidermy display.

Open Monday through Friday 10 am to 6 pm, and Saturday 10 am to 3 pm.

202 Main Street
Newport, VT 05855
(802) 334-7902

info@goodrichlibrary.org
www.goodrichlibrary.org

Green Mountain Farm-to-School

Founded in 2008 and growing rapidly, GMFTS is a leader in the farm-to-school movement, addressing issues of childhood obesity, nutrition in schools, and local food sourcing. Alongside Americorps volunteers, their staff builds school gardens, distributes local food to cafeterias and senior meal sites, and leads farm-to-school activities, including field trips, workshops, and cooking classes.

194 Main Street
Suite 301
Newport, VT 05855
(802) 334-5655
programs@gmfts.org
www.greenmountainfarmschool.org

Hillcrest Farm

Michael Rogers makes and sells organic square bales of hay for horse owners, operates a small gravel pit, leases a communication tower, and sometimes holds music festivals on the 160-acre farm his parents used for dairy farming from 1973 through 2001. There was no music festival in 2011, but hopefully the event will pick back up in 2012.

Michael Rogers
3647 Pine Hill Road
Newport, VT 05855
(802) 334-2682
michael1739@msn.com

Lago Trattoria

This award-winning restaurant serving Italian and Mediterranean cuisine also caters weddings and other events. Their menu is focused around seasonal and local ingredients, and chef/owner Frank Richardi has a close working relationship with Berry Creek Organic Farm in Westfield, among others.

Open Tuesday through Saturday 5 pm to closing.

95 Main Street
Newport, VT 05855
(802) 334-8222

Lake Memphremagog

A fresh water glacial lake located between the U.S. and Canada that provides fantastic fishing, ice fishing, camping, and boating.

www.anr.state.vt.us

Mountain Country Soap

"Home of Aging Hippie Bath & Body Products," Mountain Country sells a variety of salves, lotions, and soaps in nature-inspired scents like bergamot grapefruit, evergreen, country maple, and lavender. Shop their products at their website or their retail store.

Open Monday through Friday 9 am to 5 pm, and Saturday 9 am to 4 pm.

322 Petit Road
Newport, VT 05855
(802) 334-5394
info@mountaincountrysoap.com
www.mountaincountrysoap.com

Mountain View Stand
(see page 74)

Route 5
Newport, VT 05855
(802) 334-5545

continued on page 106

too little farm

Too Little Farm in Barnet, in the southern part of Caledonia County, is too little no longer. A stately old barn and home on a hill on Cloudy Path Road, the farm is home to a huge variety of vegetables, fruits, and animals.

When Elizabeth and Peter Everts started farming, they had just four little acres, a little house, and four little children. That's how the farm name came about. But in 1990, they bought the former dairy farm they own today. Now, they have fifty-two bountiful acres.

Their crops include hay, potatoes, oats, Swiss chard, broccoli, parsnips, asparagus, apples, pears, garlic, tomatoes, onions, gourds for decoration, raspberries, and strawberries.

Squash of many colors include giant grayish-blue Hubbard squash, yellow and tan squash, and pumpkins so deep orange they are almost red.

The Everts grow a variety of heirloom apples including Roxbury Russet, Shaw, Prairie Spy, Wealthy, Honey Crisp, and Wolf River.

The Everts raise a Jersey steer every year for beef and Dorset sheep for wool. They have turkeys and Rhode Island Red chickens for eggs. They don't sell meat but trade with neighbors and friends. They compost the animal manure as fertilizer for the gardens.

To extend the season, the Everts are building a greenhouse. Ms. Everts doesn't intend to heat it. "I've always been a patient farmer. I'm really cheap about heat and plastic."

Still, the amount of plastic in this greenhouse will make a

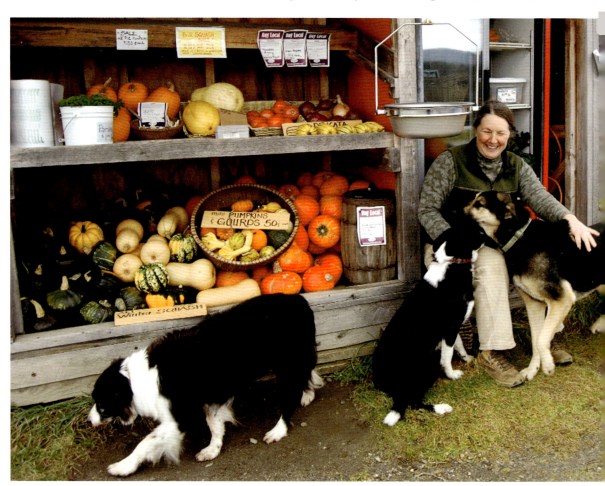

big difference in extending the growing season for Too Little Farm. "We'll be stretching our late season even later," Ms. Everts says happily.

Peter Everts is a consulting forester. Both he and his wife grew up in homes where growing their own food was part of life. "We just grew up in families that had a big garden and did a lot of hunting and fishing," says Ms. Everts. "My mom always did a lot of canning, so it just seemed kind of normal to me."

Ms. Everts said she tells people it's the way to go for healthy food that tastes better. People who come to the farmers' market want to buy high quality food from their neighbors. She runs the St. Johnsbury Farmers' Market with Curtis Sjolander of Mountain Foot Farm.

"I think a lot of farm products are pretty comparably priced, especially organic," she says. If shoppers compare the local organics to the organic supermarkets, they might be surprised to get a better deal from the farmers.

Ms. Everts sees customers who really enjoy finding out about the origins of the food they buy. "It has a story and a name behind it. It has a person. It has a place. I think that's big."

at a GLANCE

Too Little Farm in Barnet has vegetables, berries, jam, and wool products at the St. Johnsbury and Danville farmers' markets.

Elizabeth Everts
278 Cloudy Pasture Lane
Barnet, VT 05821
(802) 592-3088

below: The Everts raise turkeys, chickens, and Dorset sheep at Too Little Farm.

previous page: Elizabeth Everts plays with her dogs in front of her farm stand in Barnet.

Newport Natural Foods and Montgomery Café

The oldest continuously operated natural foods store in the North Country, this shop sells products and produce sourced from local merchants and farmers.

Store open Monday through Saturday 9 am to 5:30 pm, and Sunday 10 am to 4 pm.

Café open Monday through Friday 8 am to 2 pm, Saturday 9 am to 4 pm, and Sunday 10 am to 4 pm.

194 Main Street
Newport, VT 05855
(802) 334-2626

Royer Farm

Danny and Rose Royer sell organic haylage (hay silage) to other farmers. They also sell maple syrup at the farm and at the Troy General Store.

2522 Number 12 Road
Newport Center, VT 05857
(802) 334-6909

Woodknot Bookshop

This bookstore/café serves espresso, coffees, teas, and pastries and hosts author readings. Free Wi-Fi is available.

Open Monday through Wednesday and Saturday 9 am to 5 pm, Thursday through Friday 9 am to 8 pm, and Sunday 10 am to 5 pm.

137 Main Street, Suite 4
Newport, VT 05855
(802) 334-6720

NEWARK

Boreas Farm

Home to friendly and hardy cashmere goats, this farm produces yarn, silk yarn, and roving from hand-combed fibers.

Norma Bromley
3069 Schoolhouse Road
Newark, VT 05871
(802) 467-3222
borease25@localnet.com

Wooly Buggah Farm

At Wooly Buggah Farm, they raise a variety of sheep for wool, which they make into wool both dyed and natural. Owner Donna Coughlin knits sweaters, mittens, socks, baby bonnets, and hats that she sells online at Northeast Kingdom Country Store and at the East Burke Fall Festival in September.

182 Center Pond Road
Newark, VT 05871
(802) 467-1169
woolybug@vtlink.net

NORTH TROY

Good Life Valley Farm

(see page 50)

3206 East Hill Road
North Troy, VT 05859
(802) 673-5937
natalie@goodlifevalleyfarm.com
natsgardens@gmail.com
www.goodlifevalleyfarm.com

Mystic Meadows and Chaput Familiy Farms

(see page 24)

2473 Route 105 East
North Troy, VT 05859
(802) 988-2844

Sargent's Bear Necessities

This farm specializes in growing and selling fruit and vegetables, and making their own jams and pickles, as well. While they are not certified organic, they do follow organic growing practices. Find their produce at farmers' markets in Newport, Derby, in Morrisville, and at local health food stores.

321 Guay Farm Road
North Troy, VT 05859
(802) 988-2903
michellesargen@gmail.com
www.facebook.com/sargents-bearnecessities.com

Tastings Food & Spirits

Chef Jeffrey Weiss brings years of experience working around the world as a chef to his restaurant, Tastings. He creates American comfort food from local ingredients such as pumpkin and Cabot habenero cheddar. The restaurant offers travelers a place to stay, as well, called Valhalla Rentals.

66 Main Street
North Troy, VT 05859
(802) 988-4063
info@tastingsinvt.com
www.tastingsinvt.com

ORLEANS

Chateau Tarbox

Vermont's only organic and sustainably operated vineyard and winery handcrafts blueberry, pear, and cranberry varietals. During the summer, they provide organic fruit, vegetables, grass-fed beef, heritage breeds of pigs, and other products to the local community. The vineyard offers an in-house apprenticeship program to those who wish to learn about homestead living on the farm.

168 Tarbox Hill Road
Orleans, VT 05860
(802) 754-9506
chateautarbox@yahoo.com
www.chateutarbox.com

Vermont Beef Jerky

This company produces jerky from lean strips of beef and other choice ingredients. Four flavors are available for sale including Original, Hickory, Teriyaki, and Maple & Spice.

348 Industrial Park Road
Orleans, VT 05860
(802) 754-9412
vermontbeefjerky@yahoo.com
www.vermonter.com/beefjerky
www.alpinewebmedia.com/beef-jerkystore

Vermont Highland Cattle Company

(see page 56)

Ray Edwards
346 Industrial Park Lane
Orleans, VT 05860
(802) 754-2300
ray.edwards@vermonthighland.com

PEACHAM

Brigid's Farm

Owner Jane Woodhouse raises and works with her own wool and mohair sourced from Border Leicester cross sheep and natural colored angora goats. The farm has a studio offering six looms and a collection of spinning wheels, where she holds classes and workshops. She also specializes in natural dyeing.

Jane Woodhouse
P.O. Box 29
123 Slack Street
Peacham, VT 05862
(802) 592-3062
jane.w@fairpoint.net
jane@brigidsfarm.com
brigidsfarm@fairpoint.net

Old Shaw Farm

Certified organic vegetable farm.

Maryellen and Peter Griffin
P.O. Box 181
Peacham, VT
(802) 592-3349
peter@oldshawfarm.com

Snowshoe Farm

This farm provides full service Huacaya alpaca breeding. Products made from the animals' fleece, including yarn, roving, and raw fiber, are sold at the farm's store, at various fiber festivals, and through their website.

520 The Great Road
Peacham, VT 05862
(802) 592-3153
www.snowshoefarm.com

SOUTH RYEGATE

Blue Mountain Elk Farm

This part-time farm raises Rocky Mountain elk.

Richard Frost
100 Frost Road
South Ryegate, VT 05069
(802) 584-3187
rff-elk@juno.com

Nunivak Farm

Nunivak Farm is a small farm offering lambs, eggs, and ducks for sale, and is soon to offer Angora rabbits. The couple raise Montadale-cross sheep and sell hay bales and wool. The farm name comes from an island Ms. O'Connor and Dr. Genereaux visited in Alaska and means "land of plenty."

Jamie O'Connor and Steve Genereaux
856 Renfrew Drive
P.O. Box 54
South Ryegate, VT 05069
(802) 584-4450

SOUTH WHEELOCK

Chandler Pond Farm

Rob and Tamara Martin run this organic farm that offers a wide range of yummy foodstuffs including vegetables, fruits, dairy products, meats, and homemade sauces. Their delicious products are available at their farm stand and at surrounding local Vermont farmers' markets in Lyndon and St. Johnsbury.

528 Burroughs Road
South Wheelock, VT 05851
(802) 626-9460
info@chandlerpondfarm.com

STANNARD

Bryn Teg Farm

Judith Jones, senior editor and vice president at Knopf publishing, and her family own and operate this grass-fed cattle farm that also produces fruits, herbs and vegetables.

(802) 533-2538

ST. JOHNSBURY

American Society of Dowsers Bookstore

The ASD is a nonprofit corporation founded to espouse knowledge of dowsing (water witching, discovery of lost articles or persons, and para-psychological phenomenon) and to assemble theories, ideas, techniques, and instrumentation related to its study. The bookstore offers literature regarding dowsing and its practices.

430 Railroad Street
St. Johnsbury, VT 05819
(802) 684-3417

Catamount Arts Center

This venue houses local art shows, concerts, and performances. They also host nightly movies and programs dedicated to Vermont filmmakers.

Open daily 1 pm to 6 pm. Movies are shown each night at 7 pm (with an additional showing on Saturday at 9 pm) and matinees are Wednesdays 1:30 to 4 pm, and Sundays at 1:30 pm.

115 Eastern Avenue
St. Johnsbury, VT 05819
Toll-free: (888) 757-5559
(802) 748-2600
info@catamountarts.com
www.catamountarts.org

Dog Mountain and the Stephen Huneck Gallery

An 150-acre resort for dogs and their owners set on a private mountaintop covered with hiking trails and dog ponds. The site boasts a studio space, the Dog Chapel, and the Stephen Huneck Gallery, which offers canine-inspired trinkets, accessories, and art for dog lovers. (Stephen is the author of a charming series of books about his lab, Sally. Buy *Sally Goes to the Farm* to start!)

Spaulding Road
St. Johnsbury, VT 05819
(800) 449-2580
info@dogmt.com
www.huneck.com

Elements Food and Spirit

Chef Rich Larcom uses local ingredients from Vermont farms, purveyors, and cheesemakers to craft his simple yet elegant dishes. The restaurant hosts live music on Friday nights til 1 am.

Open Tuesday through Thursday 5 pm to 9 pm, and Friday through Saturday 5 pm to 9:30 pm.

98 Mill Street
St. Johnsbury, VT 05819
(802) 748-8400
mail@elementsfood.com

Fairbanks Museum and Planetarium

Northern New England's Museum of Natural History offers a permanent collection of science specimens, historical artifacts, and documents, as well as changing exhibits, programs, and educational services. It has the only public planetarium in Vermont.

1302 Main Street
St. Johnsbury, VT 05819
(802) 748-2372
www.fairbanksmuseum.org

Houde Family Farm

This family-run organic farm milks its own cows and raises varieties of Heritage pigs including Tamworth, Hampshire, and Hereford. The bulls from its dairy operation are raised as grass-fed veal and steers.

697 Kitchel Hill Road
St. Johnsbury, VT 05819
(802) 748-2835
houdefamilyfarm@gmail.com
www.houdefamilyfarm.com

Maple Grove Farms and Museum of Vermont

Offers an array of maple products, including confections, syrup, preserves, and salad dressing, which are for sale at their farm, on their website, and for wholesale distribution.

1052 Portland Street
St. Johnsbury, VT 05819
(802) 748-5141
maple@maplegrove.com
www.maplegroves.com

Northeast Kingdom Artisans Guild

An artisans' cooperative focused on traditional crafts. The guild exhibits a wide section of artifacts made from fiber, glass, metal, paper, and wood, and fine art including prints, watercolors, oils, and photography. The Backroom Gallery changes its exhibits every six weeks.

430 Railroad Street, Suite 2
St. Johnsbury, VT 05819
(802) 748-0158
nekguild@kingcon.com
www.nekartisansguild.com

Northeastern Vermont Development Association (NVDA)

The NVDA serves the fifty-five municipalities in the Northeast Kingdom as the Regional Planning Commission. They assist with regional and municipal land use, transportation building, and encourage sustainable economic growth as the Regional Economic Development Corporation.

P.O. Box 630
36 Eastern Avenue
St. Johnsbury, VT 05819
(802) 748-5181
info@nvda.net

St. Johnsbury Athenaeum

A private, nonprofit public library and art gallery that serves as a center for cultural enrichment and a monument to the nineteenth-century belief in learning.

Open Monday through Friday 10 am to 5:30 pm, Saturday 9:30 am to 5 pm. Closed Sunday.

1171 Main Street
St. Johnsbury, VT 05819
(802) 748-8291
www.stjathenaeum.org

St. Johnsbury Food Co-op

A community-based, cooperatively owned natural foods store selling freshly baked bread, local produce, cage-free eggs, wild fish, pasture-raised meats, local cheese, and much more.

490 Portland Street
St. Johnsbury, VT 05819
(802) 748-9498
info@stjfoodcoop.com
www.stjfoodcooop.com

Vermont Spirits VF

Hand-crafters of vodka made from locally sourced ingredients. Their Vermont Gold Vodka is made in small batches from the sugar of maple sap.

P.O. Box 272
St. Johnsbury, VT 05819
(866) 99-VODKA
ro@savvydrinks.com

WAITSFIELD

Northern Forest Canoe Trail

A 740-mile paddling route linking the waterways of New York, Vermont, Quebec, New Hampshire, and Maine that provides a variety of flat water, swift water, and whitewater rapids for canoeing and kayaking.

P.O. Box 565
Waitsfield, VT 05673
(802) 496-2285
info@northernforestcanoetrail.org
www.northernforestcanoetrail.org

WALDEN

Harvest Hill Farm

Bill Half raises and sells vegetables on his farm, mostly to employee members of CSA groups at area businesses, including the hospital in St. Johnsbury.

Bill Half
421 Watson Road
Walden, VT 05843
(802) 563-2046
gershunhalf@hotmail.com

Rowell's Sugarhouse

The sugarhouse is open every day, year-round, selling maple syrup, candy, sugar, maple cream, honey, cheese, eggs, and Vermont arts and crafts. Gloria Rowell and her husband, Norbert, and son, David, have historical sugaring equipment on display, including antique candy molds, wooden sap spouts, and a huge collection of syrup pitchers. They also raise black Angus beef cattle and hay.

4962 Route 15
Walden, VT 05873
(802) 563-2756

Walden Heights Nursery and Orchard

A certified organic farm specializing in heirloom fruit tress and plants. The proprietors graft and sell over 300 varieties of apple trees, and cultivate apples, currants, pears, grapes, hops, and a variety of berries. Produce is available for purchase at Applecheek Farm Store in Hyde Park, the Buffalo Mountain Co-op in Hardwick, and other farmers' markets. The orchard offers grower workshops, pruning and consultation, and custom grafting. Call to check availability.

120 VT Route 215
Walden, VT 05873
(802) 563-2755
waldenheightsnursery@fairpoint.net
www.waldenheightsnursery.com

WEST BURKE

Willoughby Gap Farm Stand

Sisters Janice Solinsky and Linda Britt raise and sell vegetables and one-of-a-kind crafts.

Open Tuesday through Sunday 11 am to 6 pm.

Janice Solinsky and Linda Britt
3 Lake Road
West Burke, VT 05871
(802) 467-3921
jan11_212002@yahoo.com

WEST CHARLESTON

Eden Ice Cider

(see page 38)

1023 Sanderson Hll Road
West Charleston, VT 05872
(802) 895-2838
contact@edenicecider.com

Shepherd's Crook Farm

The largest certified organic sheep farm in Vermont, the Jacksons pasture 225 sheep and are still building the flock size. They raise and sell Soay sheep, the oldest domestic breed of sheep in the world. The farm has a retail shop with lamb and sheepskin hides for sale. The Jacksons are happy to show their farm and animals to visitors, but make sure to call ahead first. The best days are Wednesdays, Thursdays, and Fridays.

Timm and Emma Jackson
2707 Hudson Road
West Charleston, VT 05872
timmnemma@hughes.net

WESTFIELD

Berry Creek Farm

Gerald and Rosemary Croizet grow and sell organic strawberries and vegetables on their farm. They also make honey, jam and beeswax candles at the Mountain View Farm Stand in Newport and Newport Natural Foods.

Route 100
Westfield, VT 05874
(802) 744-2406
berrycreekfarmvt@comcast.net
www.berrycreekfarmvt.com

Butterworks Farm
(see page 22)

421 Trumpass Road
Westfield, VT 05874
(802) 744-6855
butterwoksfarm@pshift.com

Couture's Maple Shop and Bed and Breakfast
(see page 30)

Jacques and Pauline Couture
560 Route 100
Westfield, VT 05874
Toll-free: (800) 845-2733
(805) 744-2733
jcouture@maplesyrupvt.net
www.maplesyrupvermont.com

Lazy Lady
(see page 66)

973 Snyderbroook Road
Westfield, VT 05874
(802) 744-6365
laini@sover.net

Maple View Ice Lands

The folks at Maple View produce award-winning maple syrup and raise Icelandic sheep and alpacas, known for their beautiful wool. They offer a bevy of products including hand-spun yarn, batts for spinning and felting, and both raw and washed fleece.

3489 Loop Road
Westfield, VT 05874
(802) 744-6208
mvi@together.net
www.mapleviewicelandics.com

Natural Earth Farm and Fiber Studio

A collective founded on principles of simple and sustainable living. The studio makes and sells natural fiber, hand–made toys, and rustic décor.

246 Carter Road
Westfield, VT 05874
(802) 744-6168
naturalearthfarm@netzero.net
www.naturalearthfarm.com
www.vermontbranchcompany.etsy.com

Wheeler Sugarworks / Jed's Maple Products

This sugar shack hosts school field trips, sugar on snow parties, and an open house in March during the height of sugaring season. It is also home to the Northeast Kingdom Mustard company, which produces seven varieties, including the award-winning Sweet Hot Mustard. In addition they make marinades, relish, and sauces. Call ahead to schedule a visit.

475 Carter Road
Westfield, VT 05874
(802) 744-2095
www.jedsmaple.com

WEST GLOVER

Morningstar Meadows NOFA

This second generation farm is certified organic and grows and sells heirloom bean varietites for drying. They also sell dry hay and straw, wheat and oat berries, and some vegetables. Belgian draft horses are raised and used for farming. Call ahead to schedule a visit.

165 Dwinell Drive
West Glover, VT
(802) 525-4672

Natural Earth Farms

Family-run business providing high-quality natural fiber toys and goods.

naturalearthfarm@netzero.net

The Parker Pie Company
(see page 80)

161 County Road
West Glover, VT
(802) 525-3366
www.parkerpie.com

R and B Custom Meat Cutting

Offers cutting and wrapping of every kind of meat—cut specifically to the customers' wishes. Thick or thin steaks, large roasts or small, Ray Sweeney Jr. and Bryan Lantange can handle the orders whether it's whitetail deer meat or a domestic beef. Mr. Sweeney has many years of experience cutting and packaging meat in area grocery stores.

820 Borland Road
West Glover, VT 05875.
(802) 525-4988

Rodgers Country Inn

Generations of Rodgers have lived on these rolling hills. Once farmers, now they run a charming year-round vacation bed and breakfast with a five guestroom farmhouse, large kitchen, and a

cabin that sleeps six to eight. Located near Shadow Lake. Nancy's doughnuts are locally famous, and Jim (a contractor) works as a guide for hunters in season.

Nancy and Jim Rodgers
582 Rodgers Road
West Glover, VT 05875
Toll-free: (800) 729-1704
(802) 525-6677
jnrodgers@together.net

Sweet Rowen Farmstead

Sweet Rowen's milk is pasteurized in small batches, but not homogenized (blended). The flavor is decidedly fresh, different from ultra-pasteurized milk. The milk is available at the farm and at local grocery stores and co-ops, including the C&C Supermarket in Barton and Buffalo Mountain Co-op in Hardwick.

Paul Lisai and Kelsie Sinnock
538 Lafont Road
West Glover, VT 05875
(802) 755-9960
sales@sweetrowen.com
www.sweetrowen.com

Uncle Meat's

Matt Eldridge and Nathanael Reynolds use local meat and produce whenever possible to deliver authentic southern BBQ to festivals, fairs, and other venues around Vermont.

Toll-free: (800) 594-9102
(218) 673-MEAT
(802) 525-4123
info@unclemeats.com

WESTMORE

The Willoughvale Inn

This inn, set on the shores of Willoughby Lake, is steeped in history. The restaurant's bar has recently been renamed Gil's Bar and Grill in honor of Peter Gilman, who had a tavern in the mid 1800s—the first eatery in Westmore. The Willoughvale is a beautiful old building with extensive gardens, rooms, and cabins. Fare at Gil's includes potato skins with Vermont cheddar cheese and salad with Vermont maple vinaigrette dressing. Open in summer and fall.

793 VT Route 5A South
Westmore, VT 05860
(800) 594-9102

WHEELOCK

Mountain Foot Farm
(see page 72)

154 Blakely Road
Wheelock, VT 05851
(802) 626-9471
www.mtnfootfarm.net

WOLCOTT

The Do Nothing Farm

This farm raises egg-laying chickens and pigs, and sources much of its output to local café The Bee's Knees. Hogs are fed whey from Mansfield Creamery, mash from Rock Art Brewery, and pork products are sold at retail directly from the farm.

Jay Caroli
(802) 888-9954
jay@thebeesknees–vt.com

Hardwick Beef

The company sells 100% grass-fed beef raised without antibiotics or hormones, and sourced from many family-owned farms throughout the Northeast. Available by mail order or in New York from Fresh Direct.

Hardwick Beef
(413) 477-6500
info@hardwickbeef.com

High Mowing Seeds

This wonderful company in Wolcott sows over 120 varieties of organic seeds in Vermont and over 550 varieties of organic seeds nationally, in states that include New York, Idaho, Washington, Oregon, and California. Since the kingdom is so rich, these seeds work like Jack's beanstalk—amazing. (High Mowing seeds also grace the Obama White House garden!)

Tom Stearns
76 Quarry Road
Wolcott, VT 05680
(802) 472-6174
tom@highmowingseeds.com

Sandiwood Farm

The farm is currently transitioning into agritourism, guided by the farmer's eldest daughter, a graduate of New England Culinary Institute. A catering business is in the works, as are classes in seed starting, sushi making, canning, sugaring, and smoking and curing meats. Farm tours and guests stays will be available, along with produce, jams, pickles, and cheeses for sale. Find their produce at Stowe Farmers' Market on Sundays.

Open March through November, Tuesday through Saturday 9 am to 5 pm.

1665 Town Hill Road
Wolcott, VT 05680
(802) 888-2881
maplesyrup@myfairpoint.net
www.vtpuresyrup.com

SEASONAL HIGHLIGHTS

Below, and throughout the book, we've provided a detailed listing of Northern Vermont's farms, sugar shacks, arts and culture venues, festivals, and restaurants where you can experience the best the Kingdom has to offer.

JANUARY

The Kingdom celebrates every season with events that pay tribute to maple sugaring, fall foliage, Abenaki native culture, and local history.

Christmas Bird Count (Barnet)

On New Year's Day, The Northeast Kingdom Audubon Society holds an annual bird survey in Barnet, taking routes along the Connecticut River, local farms, and dense forests. For route and information, contact Charles Brown at 802-748-2372, cbrowne@fairbanksmuseum.org.

Mount Hor Hop (Westmore)

Often the first big cross-country skiing event of the New Year. Freestyle and classic technique races held on Mount Hor at the Willoughby State Forest, hosted by the Memphremagog Ski Touring Foundation. For information and registration, visit www.mstf.net.

FEBRUARY

Bundle up and head out to the rousing winter carnivals. The whole family can enjoy ice skating, sledding, quilt shows, and dog sled rides.

Winter Carnival (Island Pond)

A weekend of all-ages ice skating, snowshoeing, ice fishing, snow sculpture contests, and other winter events. For dates and details, contact the Island Pond Chamber of Commerce at P.O. Box 255 Island Pond, VT 05846, or visit www.islandpondchamber.org.

Northeast Kingdom Ice Fishing Derby (Newport)

Ice fishing enthusiasts compete to reel in the biggest trout, salmon, pike, and perch for prestige and prizes. Register via phone or email, (802) 334-6115, wrightssports@comcast.net. For locations and times, visit www.wrightssports.com.

Snowflake Festival (Lyndon/Burke)

Two weeks of local winter events: pancake breakfasts, origami contests, sledding, quilt shows, photo contests, and more. For this year's schedule of events, contact the Lyndon Chamber of Commerce at (802) 626-9696 or visit www.lyndonvermont.com.

Winterfest and Penguin Plunge (Newport)

Skating races, dog sled rides, broomball (hockey with brooms), and the Penguin Plunge, a fundraiser for Special Olympics during which teams raise money by promising to jump into the icy waters of Lake Memphremagog for a great cause. For more information, call Janice Hogan or Andy Capello at (802) 334-6345 or visit www.kevaco.com/NEWPORTVERMONT/recreationwinterca org.

MARCH

Maple season reaches its sweet peak in March. Schedule a tour of Vermont's many sugar shacks and maple farms. You can even help tap the trees.

Lunenburg Maple Festival (Lunenburg)

In celebration of the Vermont sugaring season, Lunenburg's Top of the Common Committee hosts an annual day of pancake breakfasts, tours, raffles, tree-tapping demonstrations, and homemade soup and bread luncheons. For information, email questions@topofthecommon.org or visit www.topofthe-common.org.

Maple Open House Weekend

For one weekend in March, sugar houses across the Northeast Kingdom open their doors for public events, tours, lectures, and syrup-tastings. An index of participating locations can be found at www.vermontmaple.org.

Mountain Mardi Gras (Jay)

Jay Peak Resort hosts a northern celebration of a southern tradition: a week of skiing, costume contests, parades, ice sculptures, and Louisiana food. For details and schedules, visit www.jaypeakvermont.org or www.jaypeakresort.com.

Craftsbury Outdoor Center Gourmet Ski Tour

A twenty-five-kilometer ski tour from Highland Lodge in Greensboro to the Craftsbury Outdoor Center with gourmet food stops along the way. For details check www.craftsbury.com.

APRIL

There's nothing quite like the spring thaw in New England. Wild flowers begin to bloom and the country awakens from slumber.

World Maple Festival (St. Johnsbury)

St. Johnsbury calls itself the Maple Center of the World and invites you to visit and see why. The World Maple festival celebrates the maple syrup industry with an April weekend of festivities and competition. Call (802) 274-0201 or visit www.worldmaplefestival.org.

Green Mountain Film Festival (St. Johnsbury)

Satellite screenings of Montpelier's annual Green Mountain Film Festival held in St. Johnsbury. For venue information and advance tickets visit www.greenmountainfilmfestival.org.

Pond Skimming Celebration (East Burke)

Up to fifty costumed skimboarders compete for the titles of King and Queen of the Pond at the Burke Mountain ski resort. Contestant registration is first come, first serve! For dates and information, visit www.skiburke.com.

MAY

The long-awaited warmth gives locals and visitors alike a chance to enjoy the outdoors with friends and family.

Dandelion Run

A springtime half-marathon across verdant Vermont back roads, held annually at the height of dandelion season. Call Indoor Recreation of Orleans County at (802) 334-8511 or visit www.dandelionrun.org.

Memorial Day Parade and Spring Festival (Hardwick)

Hardwick and surrounding towns celebrate Memorial Day with a formal ceremony, parades, craft fairs, family events, barbecues, and fireworks. Visit Hardwick's municipal website at www.hardwickvt.org.

JUNE

Vermont has some of the country's best trails. Bike, hike, and camp in America's most scenic territory.

Tour de Kingdom

Five days of guided biking tours and races on scenic routes throughout the Kingdom. Proceeds support the Healthy Changes Initiative, an exercise program for senior citizens and people suffering from cancer, diabetes, heart disease, obesity, and rheumatic arthritis. Email bike@orleansrecreation.org or visit www.tourdekingdom.org.

SEASONAL HIGHLIGHTS

JULY

During the height of summer, enjoy barbeques and strawberries off the vine at one of the state's dynamic music and culture festivals.

Burklyn Arts Summer Craft Show (Lyndonville)

Burklyn Arts hosts juried summer and winter craft shows in July and December. For details, visit their website at www.burklynarts.org.

Circus Smirkus (Greensboro)

Circus Smirkus' talented international children's circus opens its tour season at its home base in Greensboro in early July and closes the tour back home in August. For more information, see www.circussmirkus.org.

Kingdom Swim (Newport)

An open water swimming event held at Lake Memphremagog every summer. Experienced (and USMS-registered) swimmers from across the country are encouraged to sign up. This is part of Aquafest, Newport's summer festival celebrating Lake Memphremagog with a street dance, bed race, fireworks, and an antique boat show. For dates, locations, and registration information, email phil@wilsonwhite.com or visit www.kingdomswim.org.

Old Stone House Big Band Dance (Brownington)

The Old Stone House Museum (a Vermont cultural landmark dating back to 1836) holds an annual big band dance fundraiser.

Craftsbury Chamber Players Concert Series

The Craftsbury Chamber Players concert series includes concerts in Greensboro, Craftsbury, and Hardwick including mini-concerts for children. For details, see www.craftsburychamberplayers.org

Irasburg Church Fair

The Irasburg Church Fair is in July with a parade, live music (bluegrass and Dixieland), pony rides, a craft tent, strawberry shortcake, and a chicken barbecue. Contact Elizabeth Beatty at (802) 754-2539.

Warebrook Contemporary Music Festival

The Warebrook Contemporary Music Festival is held each July on the 450-acre Hillandale Farm in Irasburg where composer Sara Doncaster grew up. The farm is still a working dairy farm. A cottage is available to rent. Contact them at (802) 754-6335 or email Ms. Doncaster at saracomposer@hotmail.com. Visit their website at www.warebrook.org

Stars and Stripes (Lyndonville)

An hour-long parade is the focus of this festival with music at the bandstand and a barbecue. For more information, call (802) 626-9696.

Glover Day

Glover Day is held annually on the last Saturday of July. Highlights include the Tour de Glover mountain bike race and the Runaway Pond road race, celebrating the day in history when Runaway Pond ran away. A man-made flood was created when townspeople tried to let water out of Long Pond for the mills below. Things went wrong and the whole pond flooded, but Spencer Chamberlain ran ahead of the flood to warn the town. Bread and Puppet Theater recreates the events each Glover Day with a puppet show. For more information, see grecreation.org.

AUGUST

Late summer festivals showcase Vermont's vibrance. Enjoy horse races, antique shows, craft fairs, and local produce.

Caledonia County Fair (Lyndonville)

Farm shows, truck and tractor pulls, maple displays, music, antique shows, rides, floral exhibits. For more information, visit www.caledoniacountyfair.com.

Northeast Kingdom Music Festival (Albany)

A bluegrass and camping festival hosted at the Chilly Ranch, usually held the second weekend in August. Children under eighteen must be accompanied by an adult. Attendance is limited to 2,000 people.

Orleans County Fair (Barton)

A county tradition since 1868. Horse races, tractor pulls, harness racing, demolition derbies, truck pulls, farmers' exhibitions. Visit their website at www. orleanscountyfair.net.

Craftsbury Old Home Day

The town parade goes around the Common twice in this summer celebration on the second Saturday of August. There is a craft fair, chicken barbecue, pet show, and farmers' market. For details, check out www.townofcraftsbury.com.

Moose Festival

Every August, Canaan, Vermont, Colebrook, New Hampshire, and Pittsburg, New Hampshire host a three-day Moose Festival with music, a car show, and moose stew. For more information, please call the North Country Chamber of Commerce at (603) 237-8939, email nccoc@myfairpoint.net, or visit www. northcountrychamber.org.

Old Stone House Day

Old Stone House Day is a celebration of local history each August with demonstrations of traditional methods of farming and forestry including blacksmithing and timber framing. For more information, see www. oldstonehousemuseum.org.

Echo Lake Road Race (Charleston)

The Echo Lake Road Race goes around Echo Lake in East Charleston—once around measures five kilometers, twice around is ten. All ages compete in mountain bike and running races. The race benefits Orleans County Citizen Advocacy, which pairs a community volunteer with a person who has disabilities. For more information, see www.orleanscounty-citizenadvocacy.org.

SEPTEMBER

OCTOBER

Fall brings spectacular hues to New England's landscape. The Kingdom is the perfect place to go leaf-peeping with a lover.

October in Vermont is prime time for a weekend getaway. Discover handmade crafts from local artisans as you wind your way through the region.

Craftsbury Outdoor Center's Sculling & Foliage Weekend (Craftsbury Common)

A weekend of camping, rowing, and hiking during the most beautiful period of Vermont's autumn.

Fall Foliage Festival

Towns throughout the Northeast Kingdom celebrate the changing of the seasons with local craft displays, concerts, and guided tours.

Jay Peak Annual Craft Fair (Jay)

A Columbus Day weekend display of local artisans' woodwork, paintings, jewelry, carvings, clothing, glasscraft, and more.

NOVEMBER

November is game season in the Kingdom. Endless wooded hills hold the promise of a tasty venison stew.

DECEMBER

Celebrate the holiday season with locally-baked goodies, and take your family scouting for a Christmas tree.

Thanksgiving Day Turkey Trot (Barton)

Thanksgiving races, pie sales, and prizes held as an annual fundraiser to benefit cystic fibrosis sufferers.

Rifle Season

Whitetail deer hunters take to the woods for the most popular of all the hunting seasons in the fall, rifle season, which includes two weeks—plus surrounding weekends—ending the Sunday after Thanksgiving. For more about this and other hunting seasons, visit www.vtfishandwildlife.com.

Gingerbread House Festival (Newport)

Bakers, artisans, and gingerbread enthusiasts from Vermont and afar are invited to submit their gingerbread houses for a six-day display and contest. All proceeds are donated to Northeast Kingdom Homecare's senior activity fund.

Victorian Holiday Celebration (St. Johnsbury)

A Victorian-themed Christmas celebration at the hub of Caledonia County. Wagon rides, holiday bazaars, caroling, cookie walks, and more.

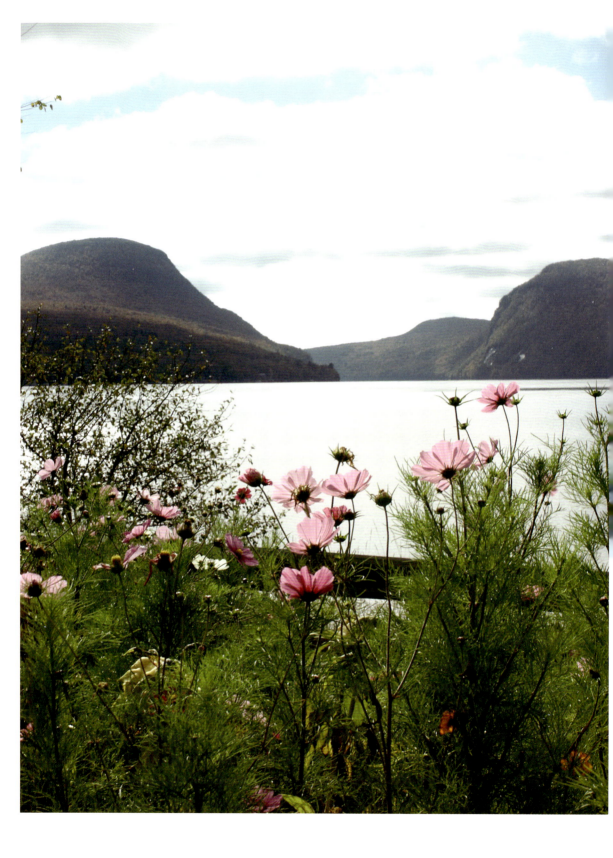

GEOLOGY

The Taconic Period (430 million years ago) witnessed the production of a major mountain range in the area we now know as Vermont, a range comparable in size to today's Rocky Mountains.

To the east sat an ancient ocean. During the years directly following the Taconic Period, known as the Silurian and Lower Devonian Period, lands east of the Green Mountains began to elongate to form a large basin filled with sand, limestone, and shale (now known as the Connecticut Valley-Gaspé Basin), which extended throughout New England and Quebec. Remnants of volcanic activity along the nearby Bronson Hill area, east of the Connecticut River in New Hampshire, provides evidence that the ancient Iapetus Ocean had all but disappeared, and that the Connecticut Valley-Gaspé Basin and the terrain of rocks to the east were converging into an area we now call the Northeast Kingdom.

This collision marked a geological period known as the Arcadian orogeny (a major mountain building event). Deep under the ground, tectonic plates collided, producing high-temperature and high-pressure conditions. These conditions caused a large-scale melting of rocks that ultimately resulted in the massive quantities of granite found near the convergence zone, including the famous Barre Granite. It was the Arcadian orogeny that brought together the land we call New England and Maritime Canada.

Millions of years later during the Pleistocene epoch, Vermont was entirely covered by a large continental glacier known as the Laurentide ice sheet that stretched from Long Island back to its source in central Quebec. It was so deep that it buried the highest peaks of the Green Mountains of Vermont.

The ice sheet started to retreat around 24,000 years ago after it reached its maximum size, and approximately 16,000 years ago the ice front of the glacier was located near the Vermont New Hampshire border. The early stages of retreat in that area led to high-level lakes, which later filled with fine-grained sediment known as glacial till. (Large swaths of till are called moraines and are found throughout Vermont.) Glaciers pick up and drop material at an incremental pace, and although Vermont's glacial ice moved from northern Canada, most of the stones found today have traveled less than twenty miles away from their original location.

Another form of glacial evidence seen in Vermont is an esker—a long, narrow, often winding ridge composed of meltwater deposits. The Passumpsic Valley esker is one of the longest and finest in Vermont and extends from St. Johnsbury northward past Lyndonville. Here, it splits into two branches: one extending up the valley of the Sutton River to West Burke, and the other snaking up the Passumpsic River valley to East Haven. In some places it is over 150 feet thick and 300 feet wide. The presence of the varves (clay deposits) above the gravels and sands of the esker indicates that deposition of sediment in the lake continued for many years after the margin of the glacier had retreated northward toward Canada.

The existence of the Glacial Lake Hitchcock in the Passumpsic River Valley was evidenced by the discovery of varves on a nearby dam that stretches from Rocky Hill, Connecticut, to north of St. Johnsbury, Vermont. Varves occur annually, as a pair of light and dark layers forms over the course of each year (the light layer being a relatively coarser-grained warm season deposit and the dark layer being a relatively finer-grained winter deposit).

From these layers, geologists are able to assess a lake's lifespan. Lake Hitchcock existed for over 4,000 years and stretched 250 miles, and was formed as glacial meltwater backed up in the Connecticut River valley behind a bedrock ridge at New Britain and a sand and gravel deposit at Rocky Hill, when the Laurentide ice sheet had retreated as far north as the Connecticut River valley. As the glacier retreated northward along the course of the river, the lake also expanded

northward, eventually stretching all the way into northern Vermont.

Although Lake Hitchcock drained approximately 12,500 years ago, its impact has endured. One can view its aesthetic consequences atop the elevated land of Newbury, Vermont, and at the breathtaking Quechee Gorge in Hartford, Vermont. Glacial remains in the form of varved lake deposits served as the raw material for the brick-making industry that flourished in the region from the nineteenth century up through the early twentieth century. Clay was dug out from a pit or bank, mixed with a small amount of sand as a binder, shaped into bricks in wooden forms, and set out to dry. After partial drying, the bricks were fired in a kiln. Clay is a dense material and was difficult to move in large quantities in the days before trucks. Therefore, nineteenth-century brickyards tended to be located on good deposits of lake clays.

The geologic history of the area has produced rocks with varying chemical properties, affecting soil development and nutrient content. In fact the Connecticut Valley has significant amounts of calcium carbonate-rich rocks (particularly metamorphosed limestone), producing calcium-rich soils essential for plant development. In addition, neutral pH levels, good moisture capacity, and drainage supply a fertile soil that supports Vermont's thriving agriculture.

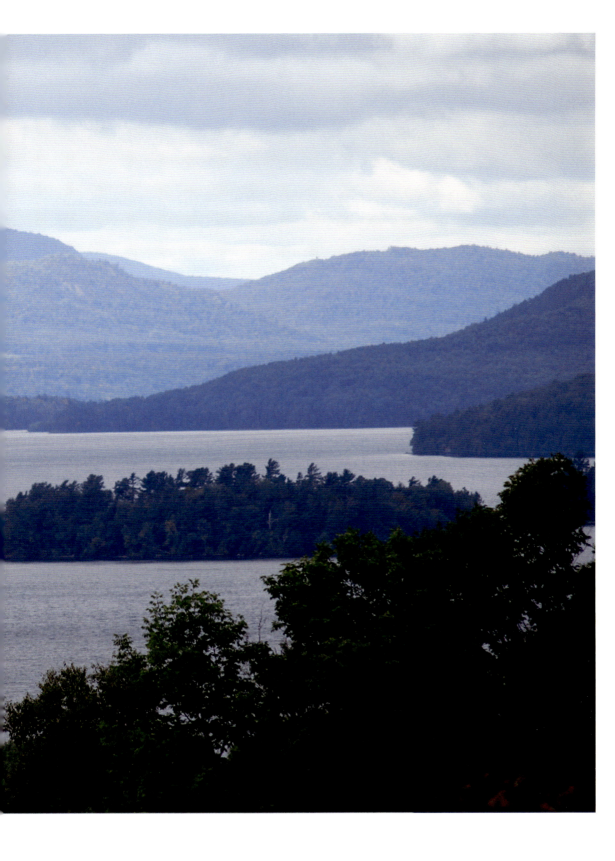

WEBSITES FOR MORE INFORMATION:

www.keeplocalfarms.org
This program helps New England dairy farmers. The site includes video profiles of farmers.

www.neklocalvores.wordpress.com
NEK Localvores includes a list of farmers' markets, a blog about eating local, and a list of related books.

www.nofavt.org
The Northeast Organic Farming Association of Vermont hosts workshops, a two-day winter conference, and lists all the organic farms of Vermont on its website.

www.ruralvermont.org
Rural Vermont is a nonprofit advocacy group. The site includes a directory of raw (unpasteurized) milk producers and more information about raw milk and the battle against genetically modified foods.

www.travelthekingdom.com
Northeast Kingdom Travel and Tourism Association is a regional marketing organization for ten area chambers of commerce and over 180 area businesses. The website has information about agritourism, geotourism, and a central reservations system. Member chambers with links on the site include: the St. Johnsbury Chamber of Commerce, the Lyndon Area Chamber of Commerce, the Hardwick Area Chamber of Commerce, the Danville Chamber of Commerce, the North Country Chamber of Commerce, the Burke Area Chamber of Commerce, the Northeast Kingdom Chamber of Commerce, the Barton Area Chamber of Commerce, the Island Pond Area Chamber of Commerce, and the Jay Peak Area Chamber of Commerce.

www.bartonchronicle.com
The Chronicle, the weekly newspaper of Orleans County, has a website with an extensive up-to-date weekly calendar of events to check when making plans. The site includes news stories, series, reviews, and profiles of local people.

www.draftanimalpowernetwork.org
This website includes information about using horses and oxen for farming, logging, and homesteading. The group hosts animal power field days in Tunbridge each fall and workshops throughout the year.

www.greenmountainfarmtoschool.org
Green Mountain Farm-to-School's site includes information about its efforts to connect schools and farms through food and education.

www.hardwickagriculture.org
The Center for an Agricultural Economy is a nonprofit that aims to strengthen the local food and agriculture systems in the region. The site includes

information on projects such as the Vermont Food Venture Center, an incubator for food-producing businesses. After Pete's Greens farm owner Peter Johnson's barn was destroyed by fire, donations came pouring in to help him rebuild. Mr. Johnson decided to consider these a loan and to pay them back into a fund to help other farmers hit by a similar disaster. With the center, Mr. Johnson established the Vermont Farm Fund.

www.vermontagriculture.com
The Vermont State Agency of Agriculture, Food, and Markets includes information about agriculture, menus, and recipes for locavores, farmers' markets, and maple producers.

www.vermontfeature.wordpress.com
Bethany M. Dunbar's blog about Vermont news.

www.vermontffa.org
The Vermont branch of a national organization for Future Farmers of America.

www.vermontfolklifecenter.org
The Vermont Folklife Center site has information about workshops, shows, publications, including *Womenspeak*—interviews with Vermont female farmers and loggers recorded and available online.

www.vermontfresh.net
The Vermont Fresh Network is a directory of Vermont restaurants and farms who serve local fresh food.

www.vsjf.org
The Vermont Sustainable Jobs Fund website includes an executive summary of a report about Vermont farmers and food called the Farm-to-Plate strategic plan, aimed to increase local jobs and help everyone gain access to healthy local food.

www.vtfb.org
The Vermont Farm Bureau started as part of a national movement in 1915. The organization fights for farmers in the political arena on causes such as a financial safety net for dairy farmers and simplifying procedures to hire immigrant workers.

BIOS

BETHANY M. DUNBAR

Bethany M. Dunbar is co-editor of *The Chronicle,* the weekly newspaper of Orleans County, Vermont, and a regular contributor of articles and photographs to *New England Country Folks.* Dunbar does a weekly live radio interview with WDEV about *The Chronicle's* top stories and appears from time to time on the Vermont Public Television news show *Vermont This Week.* She is past president of the Vermont Press Association and serves on the board. She serves on the advisory committee for Communications/Humanities for Community College of Vermont.

BILL MCKIBBEN

Bill McKibben is the author of *Eaarth, Enough, Hope, Human and Wild, Wandering Home, The Age of Missing Information,* and fifteen other titles. His first book, *The End of Nature,* was published in 1989 and has been published worldwide in over twenty languages. He writes on topics such as global warming, genetic engineering, and family.

ACKNOWLEDGMENTS

Thanks to Sarah Aubé for lots of hard work on the listings and follow-up phone calls. Thanks to Chris Braithwaite and everyone at *The Chronicle* for support and advice. Thanks to Gloria Bruce at Northeast Kingdom Travel and Tourism, Jack Lazor at Butterworks Farm, Peter Johnson of Pete's Greens, and Bethany Knight of Glover for advice and feedback. Thanks to Jennifer Hersey Cleveland for copy editing and to Tena Starr, Paul Lefebvre, Lana Bortolot, and Julia Shipley for advice and encouragement. Erica Campbell helped at the beginning of this project, when she was at the Center for an Agricultural Economy. Thanks to her, Elena Gustavson, and the rest of the folks at the Center for their help and support.

This publication is generously co-sponsored by partners and friends who we gratefully thank for their belief in the mission and in this project, especially Sally Harvey, Thomas Richardson, Andy Karsch, Sidney Kimmel, and the M.L. Ward Foundation.

Kingdom's Bounty: A Sustainable, Eclectic, Edible
Guide to Vermont's Northeast Kingdom
An Umbrage Editions Book
Kingdom's Bounty © 2012 by Nan Richardson
Photographs copyright © 2012 by Bethany M. Dunbar
Essay copyright © 2012 by Bill McKibben

First Edition
10 9 8 7 6 5 4 3 2 1
ISBN 978-1-884167-42-3
Umbrage Editions, Inc.
111 Front Street, Suite 208
Brooklyn, New York 11201
www.umbragebooks.com

An Umbrage Editions book
Publisher: Nan Richardson
Associate Editors: Calina Madden, Catherine Neckes
Editorial Assistants: Daniel Wilson, Julia Chang,
Christopher Ryan Chan, Anne Saunders
Office Manager: Valerie Burgio
Design by: Unha Kim, Takahiro Inada, Lauren Sloan
Design Assistants: Julia Gang, Irene Lau, Chelsea
Miller, Jesse Ng
Printed in China
Distributed by Consortium in the United States
www.cbsd.com
Distributed by Turnaround in Europe
www.turnaround-uk.com